高行健

高行健
Gao Xingjian

洪荒之後
After the Flood

目錄 ／
Contents ／

序 ／ 高行健

《洪荒之後》是我的一部電影短片，只有二十八分鐘，同我的另一部影片《側影或影子》一樣，也是一部電影詩，不同的是全然排除語言，影片中六位舞蹈和戲劇演員不說一句話。鏡頭以我的黑白水墨畫為背景，演員在畫面投影的銀幕前表演，基本上是黑白片，只在生命的意識再度覺醒時才給以一點淡淡的色彩。

在放映廳看過這部影片的不少朋友都對我說，感到震撼。在巴黎龐畢度中心圖書館的一次公演，觀眾的反應也非常強烈。可這部短片卻無法進入商業發行，只能在一些藝術節或我畫展的開幕式上偶爾放映。現今作為畫冊出版，把影片的 DVD 一併附上，終於有個途徑同想看這影片的觀眾見面。

2008 年拍攝的這部短片，沒想到最近在日本東北宮城海域發生的九級大地震恰恰得以印證，電視新聞中海嘯墨黑的巨潮鋪天捲地，可不正是《聖經》舊約中世界末日的景象。畫於 2006 年的我這大幅的水墨畫《世界末日》中的人們，面對從天邊湧現的黑潮如此冷靜，豈不也是現今的日本災民的某種寫照。更不可思議的是，影片中出現的第一個鏡頭，領舞的正是一位日本舞蹈演員，他也曾在我編導的戲中多次演出。

這影片不同於常見的災難片的是畫面和表演毫不寫實，也完全擺脫電影通常的敘事結構，一個個鏡頭都可以作為繪畫或攝影作品來看，其連貫性只在於動作和音響。舞台音響師迪耶利·貝托莫（Thierry Bertomeu）的音響設計不去模擬自然界的聲響，而是像寫音樂那樣用各種聲音的素材加以合成和處理，又不去構成明顯的樂句，只能說是接近音樂的音響，不僅營造氣氛，同畫面相對獨立，形成某種對位。畫面、舞蹈和音響三者無主次之分，相對自主，也即我所謂的三元電影，一種非常自由的電影詩，不像一般電影以畫面為主導，其他元素則用來解說畫面。

影片中選用的繪畫作品只有六幅是直接呈現災難，其他的畫各有主題，或是茫茫宇宙，不確定的空間，或是獨處的男女，呈現某種心象，人在沉思冥想時往往會喚起這種內心的視相。也有更趨寫意的，如《誕生》與《靜》，近乎抽象，卻還保留形象。這些畫無論接近寫實或趨於抽象，都保持在兩者之間，也是我作畫的一貫方向，不管對畫家而言還是觀眾，都可以留下足以想像的空間。之所以給個題目，也僅僅作為一點提示。

在這樣的畫面前，演員的表演只要別模擬日常生活中的舉止，可以很自由。這樣一首非語言的電影詩，詩意由畫面也還通過表演來體現，而演員又無須扮演一定的角色，只直接訴諸形體動作和表情。三位舞者和三位戲劇演員以姿態、手勢、步伐、動作、面部表情，乃至目光眼神構成語言，鮮明有力。

人類在不可阻擋的巨大的自然災害面前之無能為力，《聖經》早已作過充分的闡釋。而現代社會人類面臨的更多的是人為的災難，不斷的戰爭和動亂，生態環境日益破壞，又加上核放射潛在的威脅，人類並無有效的機制能得以避免。在宗教日益式微的現時代，人們只能在藝術中去尋求慰藉。

《洪荒之後》也是一個寓意，在自然和人為的巨大災難面前，孤單的個人，一個個男女都如此渺小，而人之為人，所以不同於草芥，只在於人有意識。如果認識到人之為人，雖然脆弱，卻也可以活得不失尊嚴，而對於人自身的確認正是藝術與文學的緣起。

人類的文明史上，藝術的誕生應該說早於文學，先有舊石器時代原始人岩洞的壁畫，而後才有歌謠和史詩。繪畫與舞蹈正是人類最早的藝術表現。形象的思維也先於語言，藝術家把這種形象思維發展到極致，繪畫不必去解說歷史或故事，就這門造型藝術而言更為純粹。舞蹈首先是情緒的表達，原本超越語言。把繪畫和舞蹈結合在一起，

構成一個個的鏡頭，就已經有其獨立的含義。

畫冊中收入的照片，是在拍攝影片時作者用高數位的相機同時拍下的，而非取之於影片的鏡頭，也可作為攝影作品。照相乃是用眼睛看，以景框為限來取景，而且是瞬間的選擇與取捨，往往來不及思考，攝影家主要訴諸視像的直覺。如果攝影家兼備戲劇導演和畫家造型的經驗，拍下的攝影作品自然會帶來又一番情趣。

這本小書集繪畫、表演、攝影和電影於一冊，除了這篇序文，都超越語言。人並非僅僅用語言思維，文學之外其他的藝術表現手段同樣也可以展示人的生存狀況，並賦予審美的判斷，藝術家的思考便寄託在藝術作品之中。這種審美判斷同訴諸語言的文學一樣，如此精微、深湛而強有力，人類生存的困境造成的悲劇與詩意同樣也得以體現。

自然和人為的災難喚起的恐懼與悲憫通過文學和藝術作品給人以解脫，從而達到精神的昇華，詩意便在其中。人面對死亡和不可知的命運，或依返宗教，或訴諸藝術，都是精神的需求。現當代人的生活愈益物質化，現實的功利無孔不入，精神的貧困成了普遍的時代病。詩意與美在當代藝術中缺席，人們已司空見慣。這本《洪荒之後》則是對精神、詩意和美的一個呼喚。

在歷經自然和人為的浩劫之後，人們重新喚起生命的意識，精神、詩意與美正象徵希望。

Foreword / Gao Xingjian

After the Flood is a short film of mine lasting only twenty-eight minutes and like my other film, Silhouette / Shadow, is also a cinematic poem, but it is different in that language is totally dispensed with, and the six dancers and actors in the film do not speak. My black-and-white paintings serve as background to the scenes, and the performers perform before a screen onto which the paintings are projected. It is basically a black-and-white film, and it is only at times when a consciousness of life reawakens that a small amount of pale colour is added.

A number of friends viewed the film in the projection room and told me that they were shaken by it, and the audience at a public screening in the library of the Pompidou Centre also reacted strongly. However, this short film cannot obtain commercial distribution and can only occasionally be screened at art festivals or at the launches of my art exhibitions. Now that this art book is to be published, a DVD of the film has been included, so at last the film can reach viewers who would like to see it.

Made in 2008, the film was unexpectedly corroborated by the huge category nine earthquake off the coast of Miyagi County in northeast Japan, where on television news monster tides of ink-black howling sea swallowed heaven and earth like scenes of the end of the world in the Old Testament of the Bible. My large ink painting End of the World, which I painted in 2006, shows people serenely facing a black tide rising from the edge of the horizon, and surely also portrays the Japanese victims of the present. And even, more incredible is that in the first scene of the film, the dancing is led by a Japanese dancer who has performed many times in plays I have directed.

The film is different from usual disaster films in that it constitutes painting and performance and is devoid of reality. The narrative structure common to film also is abandoned, so each scene can be viewed either as paintings or photographs that are linked only by movements or sounds. The sounds designed by stage acoustics expert Thierry Bertomeu do not set out to copy the sounds of the natural world, and though composed like music by synthesising and arranging sound matter, the sounds do not construct clear musical phrases, and at most may be considered sounds that approximate music. The sounds do not merely serve to create atmosphere; being also on a par with but independent of the paintings, serve as a kind of counterpoint. Neither painting, nor dance, nor sound is prioritised; each has relative autonomy, and this is what I call a tripartite film, a cinematic poem with immense freedom that is different from most films that invariably prioritise the picture and use the other elements to explain the picture.

Of the paintings chosen for the film only six directly manifest disaster, the others have their own individual themes, either the vast cosmos with its undefined space or isolated men and women who manifest certain mental images: these are all visions of the inner mind that are often evoked when one loses oneself in deep thought. There are also more expressive works like Birth and Tranquillity that verge on the abstract but still retain images. Whether the paintings are more realistic or more abstract, they remain in between the two, and this is the underlying direction of my art and the means through which ample space for the imagination is provided to both artist and viewers. I give titles merely as suggestions.

In front of paintings like these, the performers can perform with immense freedom as long as everyday movements are not simulated. In a nonverbal cinematic poem of this kind, the poetic sense is manifested through the paintings as well as the performance, so the performers do not need to act specific roles but instead resort only to body movements and expressions. The three dancers and three theatre performers construct a vocabulary that is both vivid and powerful through postures, hand gestures, steps, movements, facial expressions, and even the look of the eyes.

The total impotence of humankind before almighty, unstoppable natural disasters was fully explained in the Bible a long time ago. However, humankind in modern society to an even greater extent faces human-made disasters—those of incessant war and turmoil, the daily destruction of the ecological environment,

plus the potential threat of nuclear missiles—and there are no effective mechanisms for avoiding these. In modern times when religion diminishes by the day, people can seek comfort only in art.

After the Flood is also a message. Faced with natural and human-made disasters, solitary individuals, men and women alike, are insignificant, but what distinguishes human beings from vegetation is that humans possess a consciousness. If there is an understanding of what it is to be human, even if one is frail and weak it is possible to live without loss of dignity, and it is the affirmation of the human that is the source of art and literature.

In the history of human civilization it should be acknowledged that the birth of art precedes that of literature. At first there were the wall paintings in caves by primitive human beings during the Paleolithic era, and only afterwards ballads and epics. Painting and dance are humankind's earliest expressions of art. Thinking in images also precedes language, and artists have developed thinking in images to great heights; painting does not have to seek to explain history or stories, and it is this school of plastic art that is the more pure. Dance is primarily the expression of emotions and essentially transcends language. The combination of painting and dance in the structuring of scene after scene in a work inherently implies its independence.

The photographs collected in this art book were taken by me with a high-count digital camera during the making of the film; they are not scenes extracted from the film itself and can be regarded as photographic art. In photography the eyes select shots that are limited by the frame; moreover, it is the selection and rejection of an instant, and often there is no time for thinking so the photographer relies mainly on his or her direct perception of visual images. If the photographer has experience in directing plays and also paints as an artist, the photographs taken will of course have an added dimension of interest.

This small book brings together into a single volume painting, performance, photography and film, and apart from this preface, it transcends language. Human beings do not think merely in terms of language, and means of artistic expression other than literature can also reveal the life situations of human beings; endowed with aesthetic judgements, the artist's thinking is embodied in his artworks. As in the case of

literature that relies on language, these aesthetic judgements are subtle, profound and powerful, and similarly are able to express the tragedy and poetry created by the predicaments of human existence.

When the terror and misery caused by natural and human-made disasters are explained through works of literature and art, they are spiritually purified, and poetry is embedded within it. Human beings confronting death and an unknowable fate either return to relying on religion or resort to art, and this is because of a spiritual need. Modern and contemporary human life is increasingly materialistic, practical advantage is pervasive, and spiritual impoverishment has become the universal malaise of the times. Poetic sense and beauty have no place in contemporary art, and this is the art that people know. Nonetheless, this book, After the Flood, is an appeal for the spiritual, the poetic and the beautiful.

After experiencing natural or human-made catastrophe, an awareness of life is reawakened in people, and it is precisely the spiritual, the poetic and the beautiful that symbolise hope.

論高行健的
電影、繪畫與攝影 / 郭繼生

高行健 1940 年生於中國江西贛州，1987 年末離開北京遷居巴黎，2000 年，因其用中文創作的一組作品獲諾貝爾文學獎。諾貝爾獎評審委員會特別提到：「其作品的普遍價值，刻骨銘心的洞察力和語言的豐富機智，為中文小說和藝術戲劇開闢了新的道路。」在新聞發表會中還指出：「在高行健的作品中文學得到了新生，因為個人在群眾的歷史中經過搏鬥得以倖存。他是個睿智的懷疑論者，並不認為自己能夠解釋世界。他堅稱自己只在寫作中才找到了自由。」[1] 因為獲諾貝爾文學獎，他的文學創作得到了學者的廣泛注意，但他在電影、攝影和繪畫方面的創新尚未有系統研究。

本文著重討論高行健的電影創作，也涉及他的攝影和繪畫。我在別處已專門討論過他的水墨畫，但此處必須略微提及，為他的電影和攝影提供一個背景。[2] 他的水墨畫屬於中國文人的寫意傳統。這種獨特風格使他可以創造微妙直觀的場景和人物，介於具象與抽象藝術之間，承繼了中國藝術史上諸多大師的手法。他的畫探討水墨的各種表達性，畫中細微的濃淡層次變化、精妙的筆法和質感既充滿戲劇性又清新感人。

在電影製作方面，高行健受到英格瑪‧伯格曼、謝爾蓋‧米哈依洛維奇‧愛森斯坦、費德里科‧費里尼、皮埃爾‧保羅‧帕索里尼和安德列‧塔可夫斯基等早期電影大師的啟發，以及法國新浪潮電影（Nouvelle vague）的影響。[3] 然而，他並非是簡單效仿，在他的電影中，我們可以看到他融合了文學、繪畫和音樂，創造出他稱為的「三元電影」。高行健在《側影或影子》發表以後寫的一篇文章裡對此進行了詳細解說：所謂三元電影，便指的是畫面、聲音和語言三者的獨立自主，又互為補充、組合或對比，從而產生新的含義。基於這種認識，聲音和語言便不只是電影的附屬手段，從屬於畫面，三者分別都可以作為主導，形成相對獨立的主題；其他二者，或互相補充，或互為對比。電影也就成為這三種手段複合的藝術，而不只是一味以畫面為主導，由畫面決定一切……

畫面、聲音和語言三者倘若獨立展示各自可能達到的含義，而又不服從於敘事，每一個元素都構成自己的語彙和言語，電影便可以擺脫現今流行的模式。單就畫面來說，當畫面不再講述故事的時候，每一個鏡頭如果像繪畫和攝影作品那樣充分展示造型的趣味和影像的含義，一個個鏡頭都會變得經久耐看，也就不必匆匆忙忙切換鏡頭，去交代環境，解說事件。每一個鏡頭也就相對獨立，構成含義，甚至不必依靠聲音或語言，無聲的畫面這時候倒更有意味。[4]

高行健的《側影或影子》和《洪荒之後》兩部電影都很難歸類，但總的來說，更接近可以稱作「散文電影」和「電影詩」的作品，可以與他的水墨畫甚至可以與他的小說、短篇小說和戲劇結合起來研究。高行健的電影實踐了法國電影家亞歷山大·阿斯楚克在其重要的論文〈新前衛的誕生——攝影機鋼筆論〉（1948）中所提倡的做法。對阿斯楚克來說，將攝影機變成筆，「藝術家可以擺脫視覺形象的專制，擺脫為形象而形象，擺脫敘事的迫切具體要求，使其成為一種書寫工具，就像書面語言一樣靈活精妙……電影如今正朝著一種形式發展，這種形式使電影成為非常精確的言語，很快便可能直接在銀幕上書寫各種思想。」[5]正如電影學者諾娜·奧特爾指出：「散文[電影]努力超越形式、觀念和社會的束縛……散文電影無視傳統的界限，在結構和觀念上都打破藩籬，既內省又自反。另外，它不僅質疑電影製作人和觀眾的主觀立場，也質疑音視媒介的主觀立場——無論是電影、錄像還是數位電子。」[6]

高行健的電影屬於散文電影的傳統。他的電影顯然是典型的沃納·赫爾佐格 1999 年在明尼蘇達州明尼亞波利斯的沃克藝術中心的講座中所描述的那種形式：「電影中存在更深層的真理，存在一種詩意的、狂喜的真理。它神秘而難以捉摸，只能通過虛構、想像和風格化才能達到。」[7] 在 2006 年 10 月和 2007 年 12 月之間菲歐娜·施·拉爾潤（施湘薈）（Fiona Sze Lorrain）對高行健的一系列訪談「電影，也是文學」中有一段很有啟發的對話：

施：《側影或影子》具有很強烈很明顯的詩歌傾向。劇本的三分之一是根據你的詩歌《逍遙如鳥》：「你若是鳥，僅僅是隻鳥，迎風即起，率性而飛……」天空中翱翔的海鷗是電影中不斷出現的形象，也是整個電影的全局主題。

高：確實，電影的攝製是在詩歌完成以後開始的。這是我用法文寫的第一首詩歌……自由對我來說價值很高……當然對其他任何人也是。我早年經歷過很多磨難，覺得自己一生都在追求和爭取個人自由的表述。電影中的另一個主要主題是死亡：害怕死亡、面對死亡、脫離死亡……是的，《側影或影子》本身就是一首詩！這就是為什麼我喜歡稱這個電影為「一首電影詩」。對我來說，電影像繪畫或攝影一樣，是詩歌……電影，也是文學。[8]

確實，正如顏百君（Barbara Yien）在她的〈生活是電影詩歌藝術：高行健的《側影或影子》〉一文中很精闢地指出：「沒有線性故事，只有通過多種媒介拼貼的語彙，高行健對情感、思想和創作過程的驚人報導：電影在他的『真實』生活場景、想像的場景、詩歌的片斷、戲劇表演的片斷、他油畫的形象、音樂……和聲響中交織。」[9] 高行健的主要小說的英文譯者、高行健藝術最重要的一位研究學者李順妍（Mabel Lee）非常清楚地分析了高行健的文學、電影和繪畫創作之間的緊密關係。她引短篇小說《瞬間》為例：「高行健文學創作的一個明顯特徵是它們具有強烈的視覺和聽覺特質。這一特質在《瞬間》中尤有體現。高行健同時既是作家，又是藝術家、戲劇家、攝影師和電影師。正因如此，他的創作常常很難歸類。無論如何，《瞬間》的分類歸屬並不重要，重要的是它是一個文學文本，卻喚起一長系列強烈的視覺形象，成功地引發出一系列的情感知覺，而這正是他在這一〈電影詩歌〉中想要達到的。」[10]

也許最好還是讓高行健自己來告訴我們他想要在這個電影中達到什麼：死亡在這部影片中以三種不同的方式呈現：第一次是視覺的，死的逼近如同黑影，它來去都由不得人意，這也是一種內心的視象。第二次是戲劇的方式，劇中人對死亡的一番思考，訴諸滔滔不絕的言辭，調侃與否，哪怕那黑色的幽默也逃不脫這番歸屬。第三次，歌劇中的禪宗六祖慧能的圓寂，借助於詩的唱誦得以昇華，「這一番人生，好一場遊戲！」

童年、回憶、戰爭和災難、愛情與性與死亡、人生與藝術、存在與虛無，鏡頭與鏡頭之間已留下足夠的空間，由觀眾去詮釋。每一個場景和鏡頭都可能有多重的含義；鏡頭與鏡頭之間的剪接，又留下了想像的空間，如同讀詩。而畫外音的詩句，也令觀眾遐想或思考……[11]

高行健的第二部電影《洪荒以後》只有 28 分鐘長，2008 年完成。雖然題目表明題材是一場大災難，但這個電影並不屬於典型的災難電影，它超越了對災難的簡單描述。正如高行健本人指出：這影片不同於常見的災難片的是畫面和表演毫不寫實，也完全擺脫電影通常的敘事結構，一個個鏡頭都可以作為繪畫或攝影作品來看，其連貫性只在於動作和音響。舞台音響師迪耶利·貝托莫（Thierry Bertomeu）的音響設計不去模擬自然界的聲響，而是像寫音樂那樣用各種聲音的素材加以合成和處理，又不去構成明顯的樂句，只能說是接近音樂的音響，不僅營造氣氛，同畫面相對獨立，形成某種對位。畫面、舞蹈和音響三者無主次之分，相對自主，也即我所謂的三元電影，一種非常自由的電影詩，不像一般電影以畫面為主導，其他元素則用來解說畫面。[12]

高行健對融合繪畫和其他媒體的興趣由來已久。例如，他的劇作《八月雪》最初 1997 年是用中文寫的（2000年在台北出版），後來他為這部劇畫了一組畫，2002 年這部劇在台北上演的時候，這些畫便用作舞台背景。[13]

2006 年和 2008 年間高行健畫了一套 38 張有關《洪荒以後》的畫，這些畫既是單獨體現他藝術技巧的例子，也可視作本文開始時提到的那種媒體相互性的例子。在電影中我們看到舞者的舞動與這 38 張畫以及電影中的音樂融匯創造出一種令人難以忘懷的經驗。毫無疑問，高行健很熟悉中國古典作品中保存下來的有關洪水的神話，也熟悉中國南部和西南部少數民族中口頭流傳下來的傳說，他 1983 年曾在該地區沿著長江長途跋涉過。[14] 他的腦子裡也有世界文化中洪水的原始神話。電影不僅提醒我們面對環境重大變化時人類永遠是脆弱的，也提醒我們人類正面對的精神真空，特別是現代和當代，正如詩人葉慈所說：「我必得躺在所有梯子起始之處，在心中污穢的破布與骨頭的店鋪。」

攝影從電影起始以來與電影的豐富而複雜的關係歷史超越了本文探討的範圍。鑑於攝影作為一種藝術形式的地位在歷史上一直不穩定，以及攝影與電影的緊密關係，高行健電影中融入了繪畫和他的靜物攝影便愈加有趣。他的興趣和才能可以在他沿長江長途旅行時拍攝的很多照片中一覽無餘，這一旅行也是他的小說《靈山》的背景。在這些攝影中，表面目的常常是描繪農民生活（部分原因是為了避免政府審查），高行健卻以他敏銳的視覺捕捉中國農村和山區甚至最普通的景象中內在的雄偉。高行健在多大程度上受到 20 世紀初中國攝影美學的影響還有待於進一步研究，[15] 但是他已發表的攝影作品已足以使我們看到高行健的深刻見解，他在普通人的日常生活中看到了崇高，這是超越既定制度控制之外的深刻見解。在為慶祝他獲諾貝爾獎十週年出版的高行健小說中文版裡收入了他的攝影精選作品，加深了我們對這部文學鉅作的理解。[16]

像他的水墨畫一樣，來自《洪荒以後》的攝影體現了他不斷努力探索具象與抽象之間那模糊而有潛力的空間。與很多早期的攝影師不同，如亨利·卡蒂爾—布列松（在他著名的 1932 年《巴黎聖拉札爾火車站後面》裡）非常重視時間的瞬間與照相機的關係，而高行健卻用照相機在每張照片裡創造出虛擬的時刻，就好像真實的瞬間一樣。

高行健的作品顯示，他在不斷努力跨越邊界。他已經跨越的「邊界」不僅僅是那些標誌地理和政治分界的界線，而且是與藝術媒體、文學類別和文化相關的界線。應該指出，我們如今生活在一個媒體介間的時代，各種媒體「互相之間」、「兩者之間」，「差別」、「不可通約性」都越來越受到質疑。高行健的文學、電影、攝影和繪畫藝術使我們洞悉到人類的共同狀態。

注釋

1. 2012 年 11 月 17 日取自 http://www.nobelprize.org/nobel_prizes/literature/ laureates/2000/press.html。

2. 郭繼生，《內在的風景：高行健的水墨畫》，華盛頓新學術出版社，2013 年。也請參閱李順妍見解深刻的論文〈高行健繪畫的美學層面〉，見《高行健：具象與抽象之間》，聖母大學史納德藝術博物館，2007 年，頁 125-145。

3. 菲歐娜・施・拉爾潤（施湘雲），「〈電影，也是文學〉：與高行健交談」，2012 年 11 月 2 日取自 http://mclc.osu.edu/rc/pubs/sze.htm。

4. 高行健著，李順妍譯《美學與創作》，紐約州阿姆赫斯特，坎木布里出版社，2012 年，頁 180-181。

5. 轉載於提莫西・考里根、帕特麗夏・懷特和米塔・瑪札耶編，《電影理論的批判的視野：古典和當代閱讀材料》，波士頓，貝德福德／聖馬丁出版社，2011 年，頁 352。

6. 諾娜・奧特爾，〈散文電影中難以／可以覺察的政治：法洛基的世界圖像與戰爭銘文〉，載《新德國批判 68》（春夏，1996 年）頁 165-192，頁 171。

7. 沃納・赫爾佐格，〈明尼蘇達宣言〉；2013 年 7 月 12 日取自 http://www.wernerherzog.com/117.html#c268; 有關散文的簡潔討論請參閱提莫西・考里根的《散文電影：來自蒙田，追隨馬克》，牛津，牛津大學出版社，2011 年。

8. 2012 年 11 月 22 日取自 http://mclc.osu.edu/rc/pubs/sze.htm。

9. 2012 年 12 月 2 日取自 http://www.cerisepress.com/01/01/life-as-art-as cinepoem-gao-xingjianssilhouette-shadow。

10. 李順妍，〈高行健的電影《側影或影子》的背景〉，2013 年 7 月 22 日取自 http://mclc.osu.edu/rc/pubs/lee.htm；高行健，《高行健短篇小說集》，台北，聯合文學出版社，2001 年，頁 311-338。

11. 高行健，《美學與創作》，頁 186。

12. 高行健，《美學與創作》，頁 222。

13. 高行健，《八月雪》（台北，聯經出版公司，2001 年）；方梓勳英譯《八月雪》，香港中文大學出版社，2003 年。

14. 有關洪水的神話大約有 50 個不同版本，請參閱安妮・比羅的《中國神話》（奧斯丁，德克薩斯大學出版社，2000 年，頁 33-35，頁 70。

15. 羅清奇 (Claire Roberts)，《攝影與中國》，倫敦，李克訊書籍，2013 年，特別是頁 65-90。

16. 高行健，《靈山》，台北，聯經出版公司，2010 年。應該指出，《靈山》的第一版是 1990 年出版的，李順妍的英譯本根據第一版翻譯，2000 年由紐約哈珀柯林斯出版社出版。

On Gao Xingjian's Films, Paintings and Photographs / Jason C. Kuo

Gao Xingjian (born in Ganzhou, Jiangxi Province, China in 1940) relocated from Beijing to Paris in late 1987. In 2000 he was awarded the Nobel Prize for a body of works he had written in the Chinese language. The Nobel Prize selection committee noted that he had been selected "for an oeuvre of universal validity, bitter insights and linguistic ingenuity, which has opened new paths for the Chinese novel and drama." The committee's press release states that: "In the writing of Gao Xingjian literature is born anew from the struggle of the individual to survive the history of the masses. He is a perspicacious skeptic who makes no claim to be able to explain the world. He asserts that he has found freedom only in writing."[1] Although his Nobel award has brought scholarly attention to his literary creations, his innovations in film, photography and painting, and his thought-provoking essays on his creative endeavors remain to be systematically subjected to critical study.

This essay focuses on his films with reference to his photographs and paintings. I have written elsewhere more specifically about his ink paintings, but I must say a few general words about his paintings here to provide a context for his films and photography.[2] His style of ink painting belongs to the great Chinese literati tradition of xieyi (literally "writing the idea"). This particular style allows him to create subtle, intuitive settings and characters that move in the limits between figurative and abstract art, in a way that has been done by many of the great masters in Chinese art history. His paintings explore the expressive possibilities of ink and washes, and the nuanced light and dark shadings, subtle washes, and textures in his paintings are both dramatic and refreshing.

In his filmmaking, Gao Xingjian was inspired by earlier masters such as Ingmar Bergman, Sergei Mikhailovich Eisenstein, Federico Fellini, Pier Paolo Pasolini, Andreï Tarkovsky and by the films of the French New Wave (*Nouvelle vague*).[3] However, he did not simply follow them: in his films, we see the integration of literature, painting, and music to create what he calls "tripartite film." He has elaborated on this in an essay written after *Silhouette/Shadow* was released: What I call a tripartite film refers to the picture, sounds, and language, each having independence and autonomy, but each complements, combines with, and contrasts with the others to produce new meanings. In this understanding, sounds and language cease to be subsidiary components that are subordinate to the picture. Instead, each of the three can predominate to form a relatively independent theme, and the other two serve to complement or contrast. In this way, film becomes a composite art of all three components and not simply one in which the picture always prevails and determines everything...

If picture, sounds, and language each functions to its fullest potential, each no longer subservient to narrating events, each creating its own vocabulary and language, then the film will be able to break away from the current popular mould. With reference to the picture, if it no longer tells a story and if each scene—just like paintings and photographs—fully manifests the charm of plastic art and the meaning of photography, then each scene will be worth savouring and there would be no need or rush to change scenes merely for the sake of explaining events. In this way, each scene is relatively independent and structures its own meaning without the help of either sounds or language. At such times, a soundless screen can be even more interesting.[4]

Gao Xingjian's two films, *La Silhouette sinon l'ombre* (*Silhouette/Shadow*) and *Après le deluge* (*After the Flood*), are hard to classify but, generally speaking, are more akin to what can be called "essay films" or "cine-poems" and can be studied in conjunction with not only his ink paintings but also his novels, short

stories, and plays. Gao Xingjian's films put into practice what Alexandre Astruc advocates in his seminal essay "The Birth of a New Avant-Garde: La Caméra-stylo" (1948). For Astruc, by turning the camera into a pen, artists can "break free from the tyranny of what is visual, from the image for its own sake, from the immediate and concrete demands of the narrative, to become a means of writing, just as flexible and subtle as written language… The cinema is now moving towards a form which is making it such a precise language that it will soon be possible to write ideas directly onto film."[5] As the film scholar Nora Alter puts it, "The essay [film]…strives to be beyond formal, conceptual, and social constraint…the essay film disrespects traditional boundaries, is transgressive both structurally and conceptually, is self-reflective and self-reflexive. It also questions the subject positions of the filmmaker and audience as well as the audiovisual medium itself—whether film, video, or digital electronic."[6]

Gao Xingjian's films belong to the tradition of essay films. It is very clear that his films exemplify what Werner Herzog described in a lecture at the Walker Art Center, Minneapolis, Minnesota in 1999: "There are deeper strata of truth in cinema, and there is such a thing as poetic, ecstatic truth. It is mysterious and elusive, and can be reached only through fabrication and imagination and stylization." [7] In "'Cinema, Too, Is Literature': Conversing with Gao Xingjian," a series of interviews with Gao Xingjian (GXJ) by Fiona Sze Lorrain (FSL) between October 2006 and December 2007, there is a revealing conversation on Silhouette/ Shadow:

FSL: Silhouette/Shadow has a very strong and evident poetic bent. One third of its script is based on your poem, *Way of the Wandering Bird (L'Errance de l'oiseau)*: "If you are a bird / No more than a bird / With the wind's first breath / You fly away..." The recurring motif of a gull soaring high in the sky is also an overarching theme in the entire film.

GXJ: Well, the filming phase began when I completed the poem, L'*Errance de l'oiseau*. This was my first free verse poem written in French... Liberty is very valuable to me... and to anyone else too, of course. I had suffered a lot of hardship in my earlier years, and I believe my entire life is a statement about searching and obtaining individual freedom. Another principal theme in the film is death: fearing it, confronting it, walking away from it. ...Yes, Silhouette/Shadow is in itself a poem! That is why I prefer to call this film "a

cinematic poem." To me, cinema, like painting or photography, is poetry... Cinema, too, is literature.[8]

Indeed, as the critic Barbara Yien observes perceptively in her essay "Life as Art as Cinepoem: Gao Xingjian's *Silhouette/Shadow*": "There's no linear story here, but rather Gao's astonishing reportage of emotion, thought, and the creative process, told through the vocabulary of multimedia collage: the film interweaves scenes from his 'real' life, scenes from his imagination, excerpts from his poems, excerpts from theater performances he scripted, images from his oil paintings, music . . . and sound."[9] Mabel Lee, translator into English of Gao Xingjian's major fictional writings and one of the most important scholars of his art, has written lucidly about the intimate relationship between Gao Xingjian's literary, cinematic, and painterly creations. She cites the short story "In an Instant" as an example: "A distinctive feature of Gao Xingjian's literary creations is that they have a strong audiovisual quality. This unique quality is manifest in 'In an Instant.' Gao Xingjian is at once writer, artist, dramatist, photographer, and filmmaker, and it is for this reason that his creations often defy conventional generic classifications. In any case, the generic classification of 'In an Instant' is less important than the fact that it is a literary text that evokes a prolonged series of powerful visual images that succeed in triggering a wide range of sensations, as is Gao Xingjian's intention in this 'cinematic poem.'"[10]

Perhaps it is best to let Gao Xingjian himself tell us what he wanted to accomplish in this film: The film manifests death in three modes. First, it is visual. Imminent death is like a black shadow, and its coming or going is not as one wills: this is an image of the inner mind. Next, it appears in the theatrical mode. In the play, the deliberations on death are embedded in an endless stream of words, although the mockery and black humour remain within death's jurisdiction. And finally, it appears in the death of the Sixth Chan Buddhist Patriarch in the opera and his ascent unto the sublime accompanied by the chanting of poetry, "Life is a wonderful game!"

Childhood, recollections, war and disaster, love and sex, as well as death, life, and art, existence and nonexistence: between these scenes, there is ample space for viewers to insert their own interpretations. Each event and scene can have many layers of meaning, and the montage between scenes leaves further space for the imagination, just as when one reads poetry. And the sound of poetry external to the picture

also provokes flights of fancy or profound contemplation. ...[11]

His second film, lasting for only 28 minutes, is entitled *Après le deluge (After the Flood)*, and was completed in 2008. Although the title suggests that it deals with a great disaster, it does not belong to the typical cinema of catastrophe; it actually goes beyond a simple depiction of disaster. As Gao Xingjian himself points out, The narrative structure common to film also is abandoned, so each scene can be viewed either as paintings or as photographs that are linked only by movements or sounds. The sounds designed by stage acoustics expert Thierry Bertomeu do not set out to copy the sounds of the natural world, and though composed like music by synthesising and arranging sound matter, the sounds do not construct clear musical phrases, and at most may be considered sounds that approximate music. The sounds do not merely serve to create atmosphere; being also on a par with but independent of the paintings, they serve as a kind of counterpoint. Neither painting, nor dance, nor sound is prioritized; each has relative autonomy, and this is what I call a tripartite film, a cinematic poem with immense freedom that is different from most films that invariably prioritize the picture and use the other elements to explain the picture.[12]

Gao Xingjian has long been interested in the integration of painting and other media. For instance, for his play *Snow in August* first written in Chinese in 1997 (published in 2000 in Taipei), he completed a series of paintings later used in the stage production of the play in Taipei in 2002.[13] Between 2006 and 2008, he completed a series of thirty-eight paintings related to the theme of the film *Après le deluge (After the Flood)*. These paintings that can stand alone as excellent examples of Gao Xingjian's artistry in ink painting can also be seen as examples of his interest in intermediality mentioned at the beginning at this essay. In the film itself, we see dancers' dynamic movements integrating with these thirty-eight paintings and music in the film to create a haunting experience confronting all human beings. Undoubtedly Gao Xingjian is familiar with the flood myth preserved in the ancient Chinese Classics as well as in the oral traditions of minority groups in South and Southwest China where he took his long journey along the Yangtze River in 1983.[14] He has in mind also the primordial myth of flood in world culture. The film not only reminds us of the perennial nature of human vulnerability in the face of environmental changes of gigantic proportion but also of the spiritual vacuum confronting all human beings, particularly in the modern and contemporary world in which, as Yeats once put it, "Now that my ladder's gone, / I must lie down where all ladders start, /

In the foul rag-and-bone shop of the heart."

The rich and complicated history of the relationship between photography and cinema, from the latter's earliest days, is beyond the scope of this essay. Given the historical ambivalence of the status of photography as an art form and its intimate relationship to cinema, the integration of painting into Gao Xingjian's film, as well as the still photographs he took, is fascinating. His interest and talent can be clearly seen in the many photographs he took during his long journey along the Yangtze that forms the background of his novel Soul Mountain. In these photographs, taken often for the ostensible purpose of portraying the peasants (in part to avoid government censorship), Gao Xingjian employs his visual acuity to capture the inherent monumentality of even the most common sight in the rural and mountainous regions of China. The extent to which Gao Xingjian was under the influence of the aestheticism in early twentieth-century Chinese photography remains to be studied,[15] but his published photographs are sufficient to give us Gao Xingjian's insightful observation of the sublime in the quotidian experience of the common people that is beyond the control of the established institutions. Selections from the large number of photographs he had taken were included in the Chinese edition of the novel published to celebrate the tenth anniversary of his Nobel Prize, and enhance tremendously our reading of the literary masterpiece.[16]

Like his ink paintings, his photographs derived from the making of *Après le deluge (After the Flood)* exemplify his continued efforts to explore the ambiguous but potent space between figurative and abstraction. Unlike many earlier photographers such as Henri Cartier-Bresson (as in his famous 1932 *Behind the Saint-Lazare Station, Paris*) who take the relationship between time and camera seriously, Gao Xingjian creates in each of the photographs fictional moments for the camera and makes a photograph as if it were an instant in reality.

The work of Gao Xingjian indicates his continued efforts in border-crossing. The "borders" he has crossed are not only those that mark geographic and political boundaries but also the borders associated with artistic media, literary genres, and cultures. It should be noted that we are now living in an age of "intermediality" in which the "inter," the "gap," the "in-between," the "incommensurability" between media have been increasingly called into question. Gao Xingjian's art in fictional writings, films, photographs, and paintings give us insights into our common human condition.

Notes

1. http://www.nobelprize.org/nobel_prizes/literature/laureates/2000/press.html; accessed November 17, 2012.

2. Jason C. Kuo, *The Inner Landscape: The Ink Paintings of Gao Xingjian* (Washington, DC: New Academia Publishing, 2013). See also Mabel Lee's insightful essay "Aesthetic Dimensions of Gao Xingjian's Painting," in *Gao Xingjian: Between Figuration and Abstract* (Notre Dame, IN: Snite Museum of Art, University of Notre Dame, 2007), pp. 125-145.

3. Fiona Sze Lorrain, "'Cinema, Too, Is Literature': Conversing with Gao Xingjian"; http://mclc.osu.edu/rc/pubs/sze.htm; accessed November 22, 2012.

4. Gao Xingjian, *Aesthetics and Creation*, translated by Mabel Lee (Amherst, NY: Cambria Press, 2012), pp. 180-181.

5. Reprinted in Timothy Corrigan, Patricia White, with Meta Mazaj, ed., *Critical Visions in Film Theory: Classic and Contemporary Readings* (Boston: Bedford/St. Martins, 2011), p. 352.

6. Nora Alter, "The Political im/perceptible in the Essay Film: Farocki's Images of the World and the Inscription of War," *New German Critique 68* (Spring-Summer, 1996), 165-192, at 171.

7. Werner Herzog, "Minnesota Declaration"; http://www.wernerherzog.com/117.html#c268; accessed July 12, 2013. For a succinct discussion of the essay film, see Timothy Corrigan, The Essay Film: From Montaigne, After Marker (Oxford: Oxford University Press, 2011).

8. http://mclc.osu.edu/rc/pubs/sze.htm; accessed November 22, 2012.

9. http://www.cerisepress.com/01/01/life-as-art-as-cinepoem-gaoxingjians- silhouette-shadow; accessed December 2, 2012.

10. Mabel Lee, "Contextualizing Gao Xingjian's Film Silhouette / Shadow"; http:/mclc.osu.edu/rc/pubs/lee.htm; accessed July 22, 2013; Gao Xingjian, *Gao Xingjian duanpian xiaoshuo ji* (Taipei: Unitas Publishing Co. , 2001), pp. 311-338.

11. Gao Xingjian, *Aesthetics and Creation*, p. 186.

12. Gao Xingjian, *Aesthetics and Creation*, p. 222.

13. Gao Xingjian, *Bayue xue* (Taipei: Linking Publishing Co. , 2001); *Snow in August*, translated by Gilbert C. F. Fong (Hong Kong: The Chinese University of Hong Kong Press. 2003).

14. There are close to fifty versions of the flood myth; see Anne Birrell, *Chinese Myths* (Austin: University of Texas Press, 2000), 33-35, 70.

15. Claire Roberts, *Photography and China* (London: Reaktion Books, 2013), especially pp. 65-90.

16. Gao Xingjian, *Lingshan* (Taipei: Linking Publishing Co. , 2010). It should be noted that the first edition was published in Taipei in 1990 and was the basis for Mabel Lee's English translation published in 2000 as *Soul Mountain* (New York: HarperCollins, 2000).

洪荒之後
After the Flood

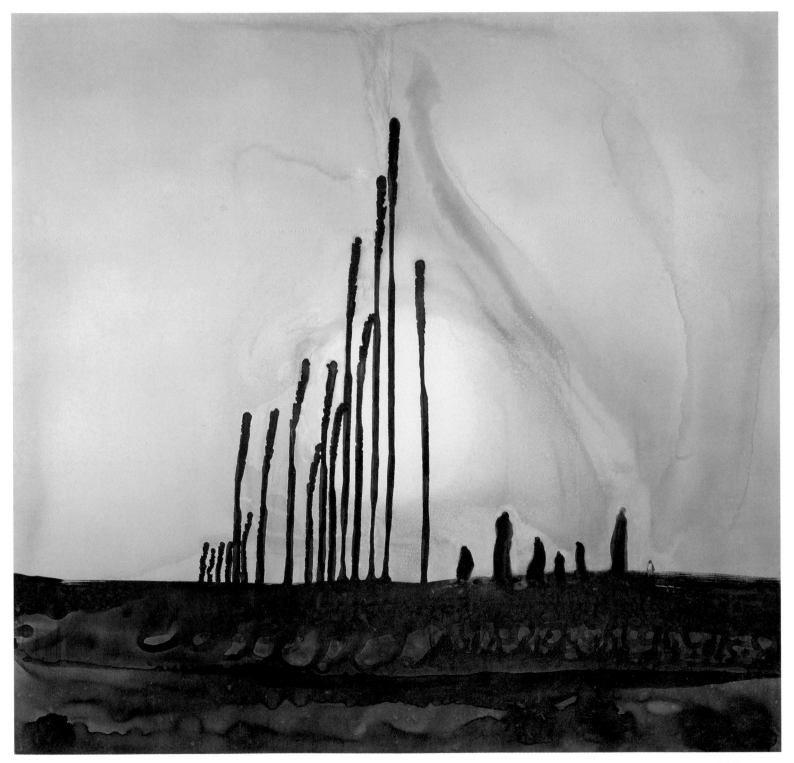

預兆 ◀2006
The Omens, 2006
Ink in Canvas, 192 cm x 200 cm

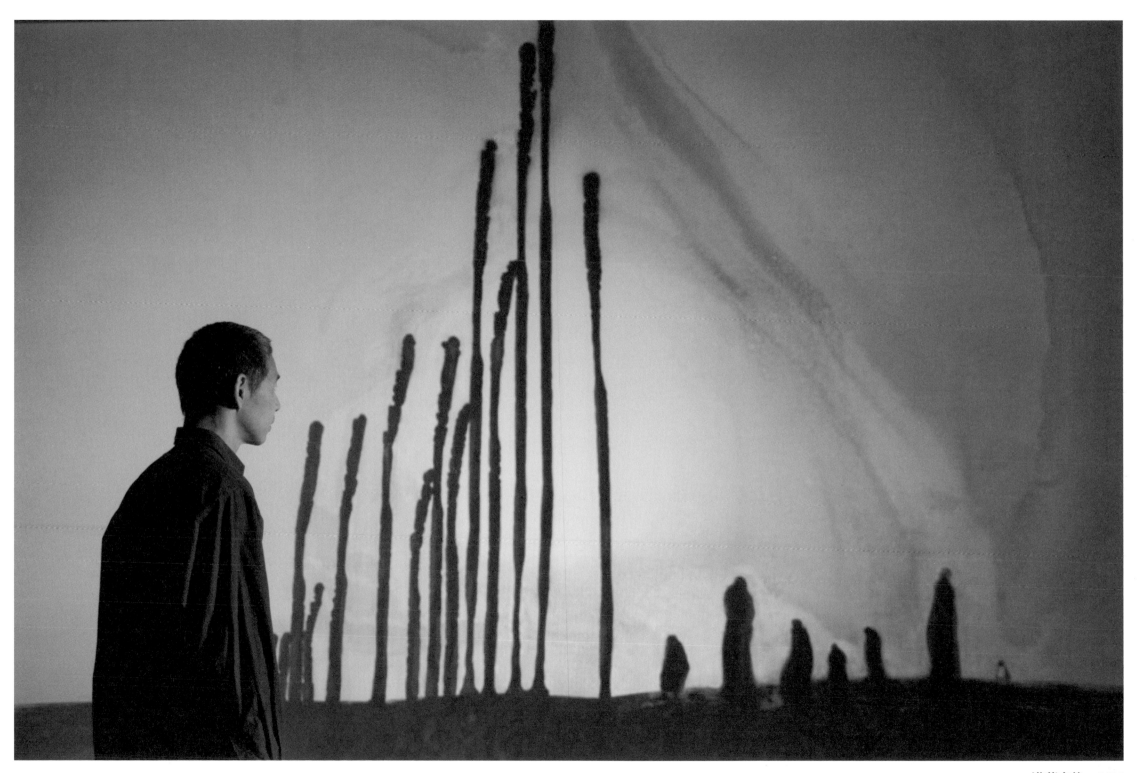

洪荒之後，2008
After the Flood, 2008

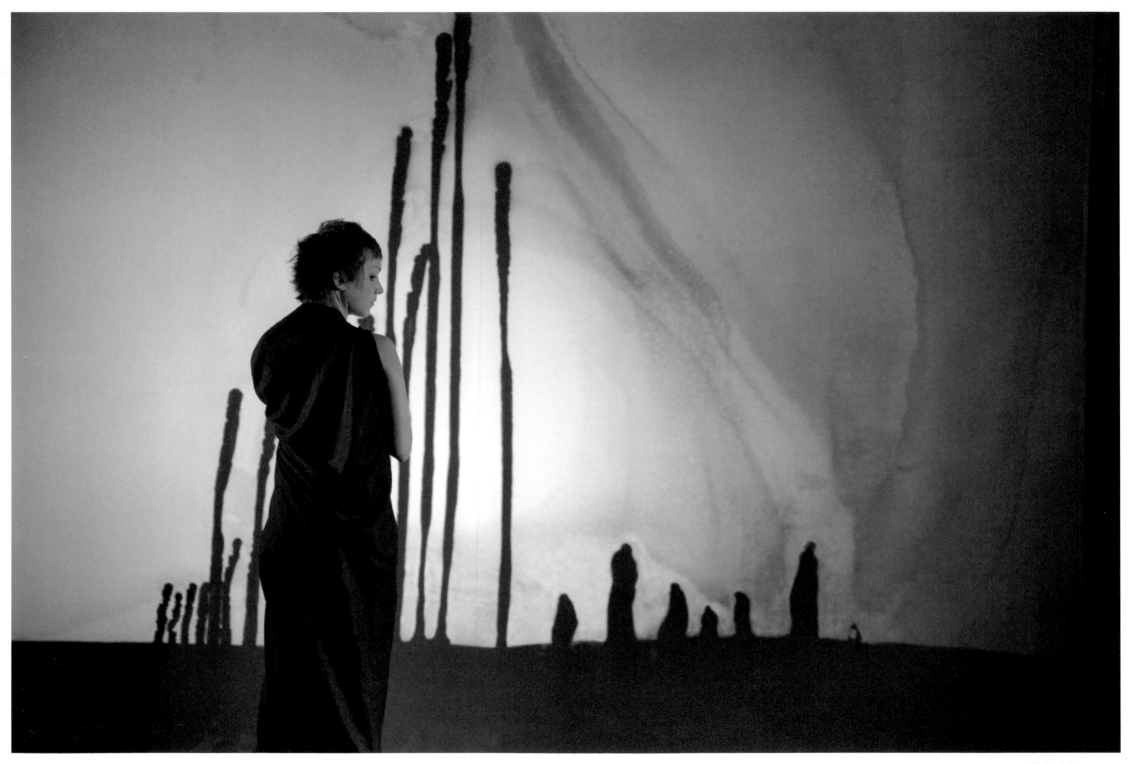

洪荒之後，2008
After the Flood, 2008

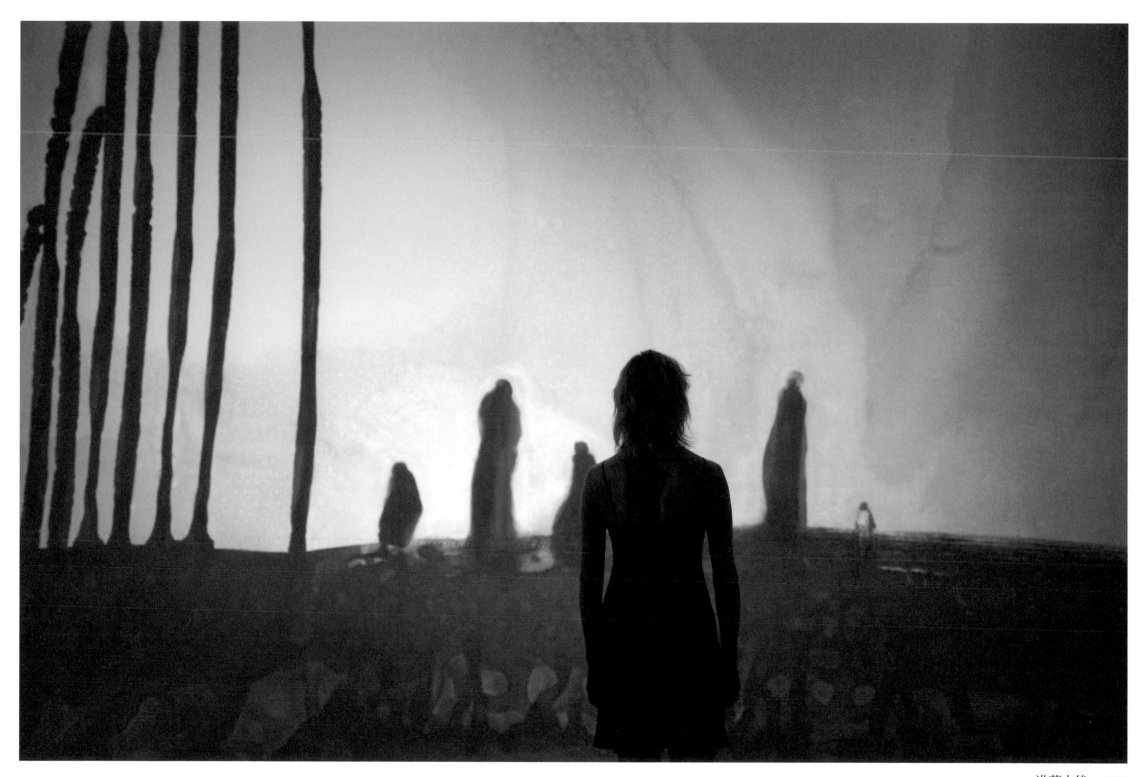

洪荒之後，2008
After the Flood, 2008

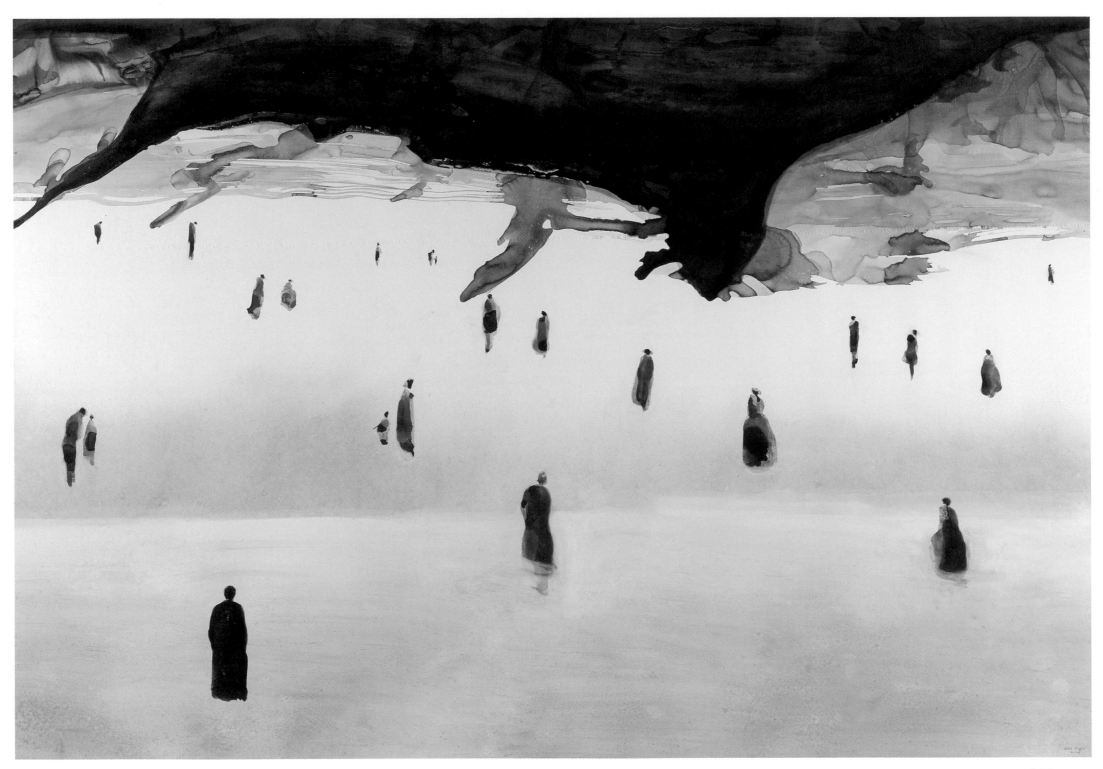

末日，2006
The End of the World, 2006
Ink in Canvas, 240 cm x 350 cm

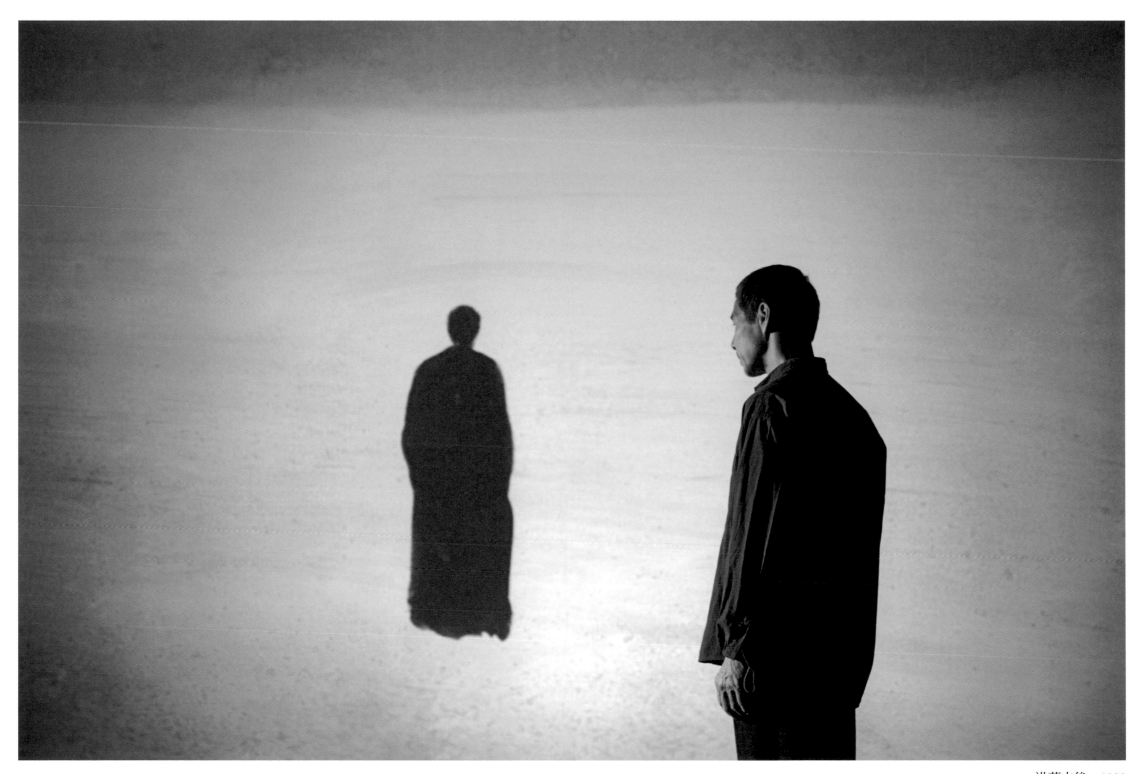

洪荒之後，2008
After the Flood, 2008

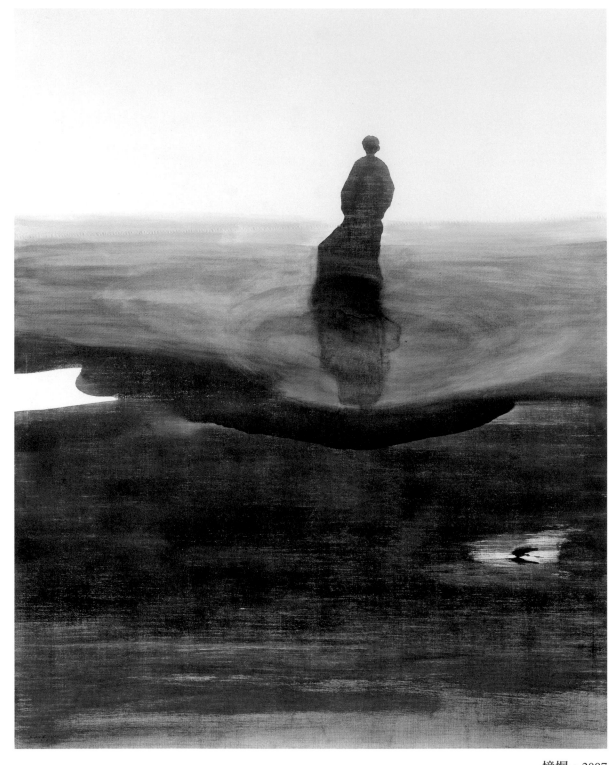

憧憬，2007
Yearning, 2007
Ink in Canvas, 162 cm x 130 cm

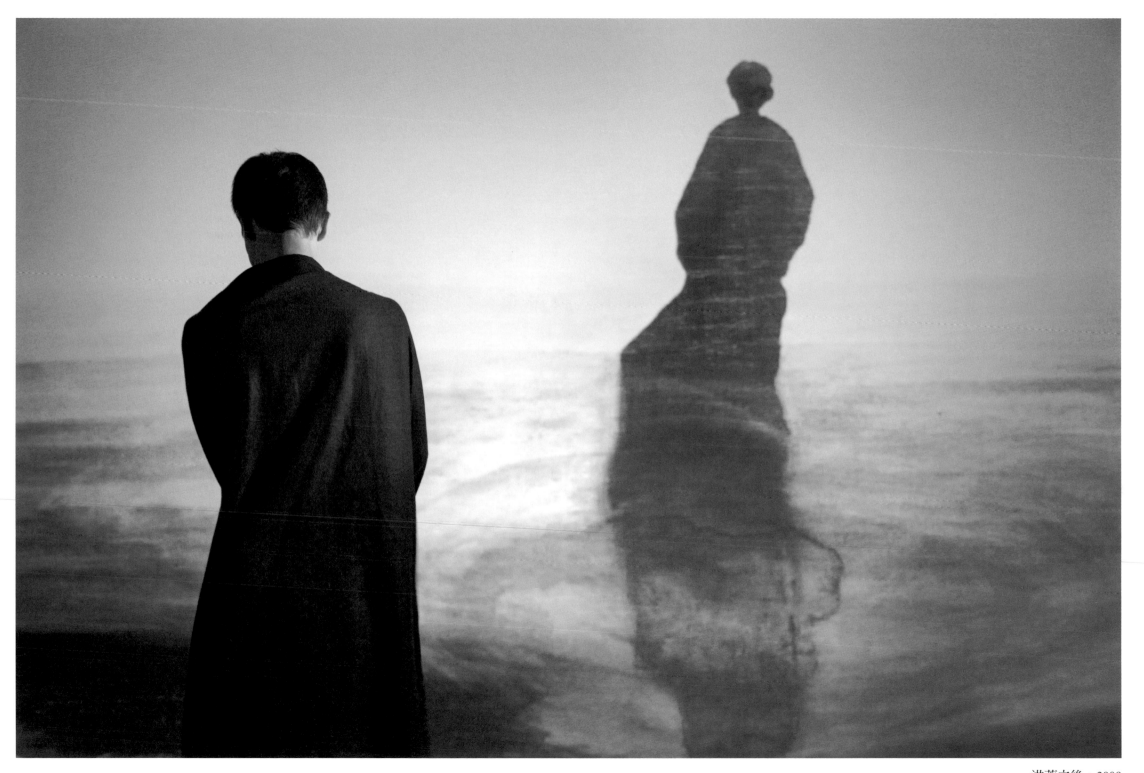

洪荒之後，2008
After the Flood, 2008

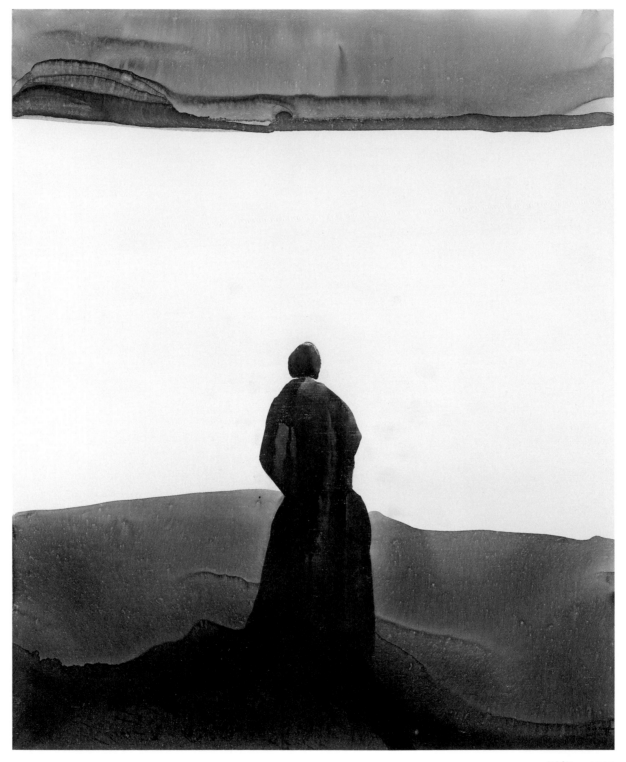

展望，2007
Prospect, 2007
Ink in Canvas, 162 cm x 130 cm

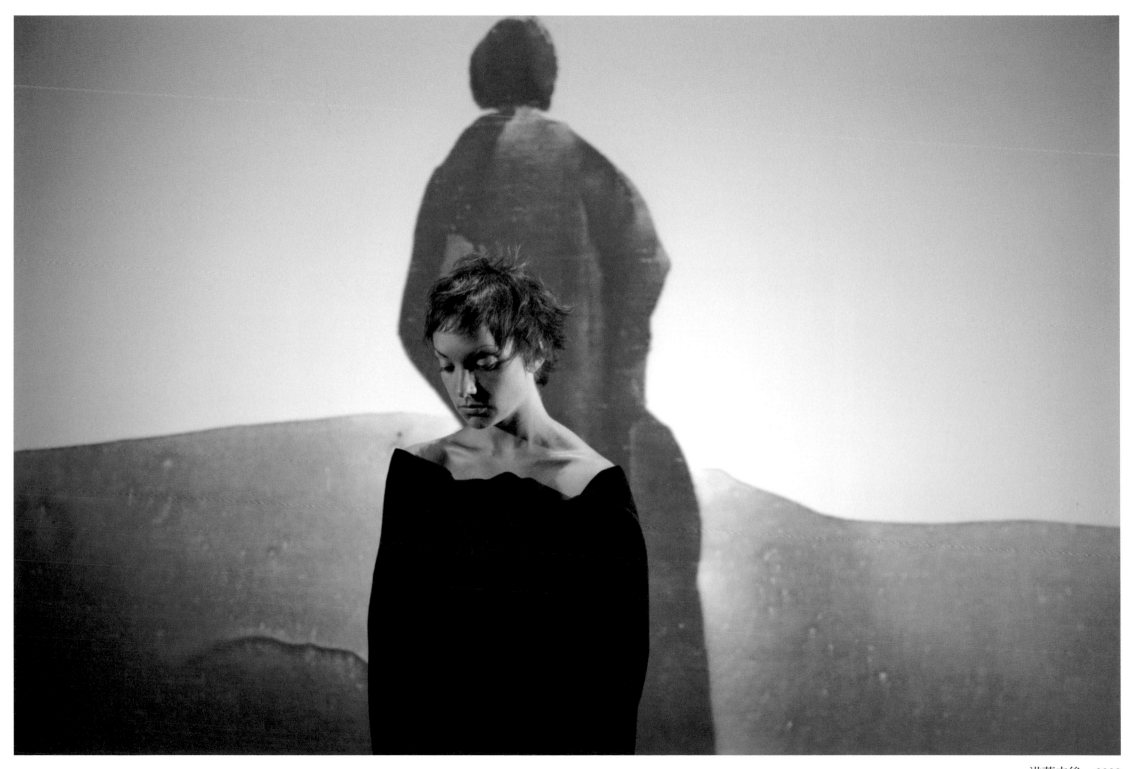

洪荒之後，2008
After the Flood, 2008

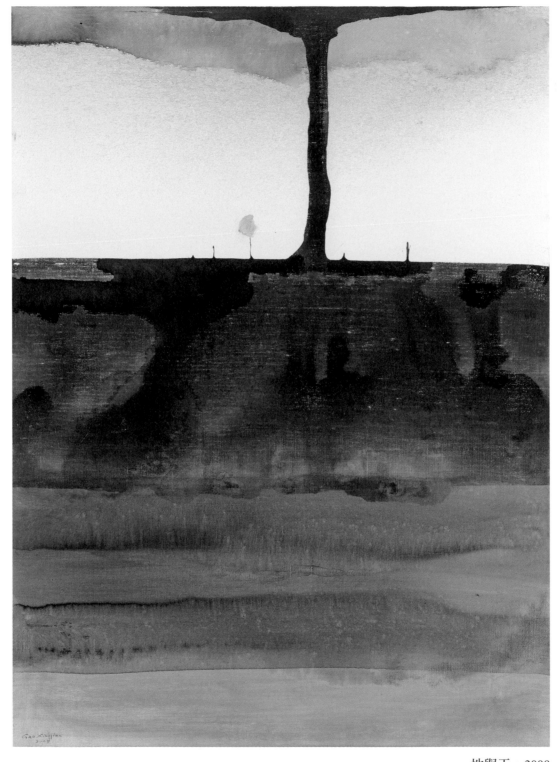

地與天，2008
Earth and Sky, 2008
Ink in Canvas, 100 cm x 73 cm

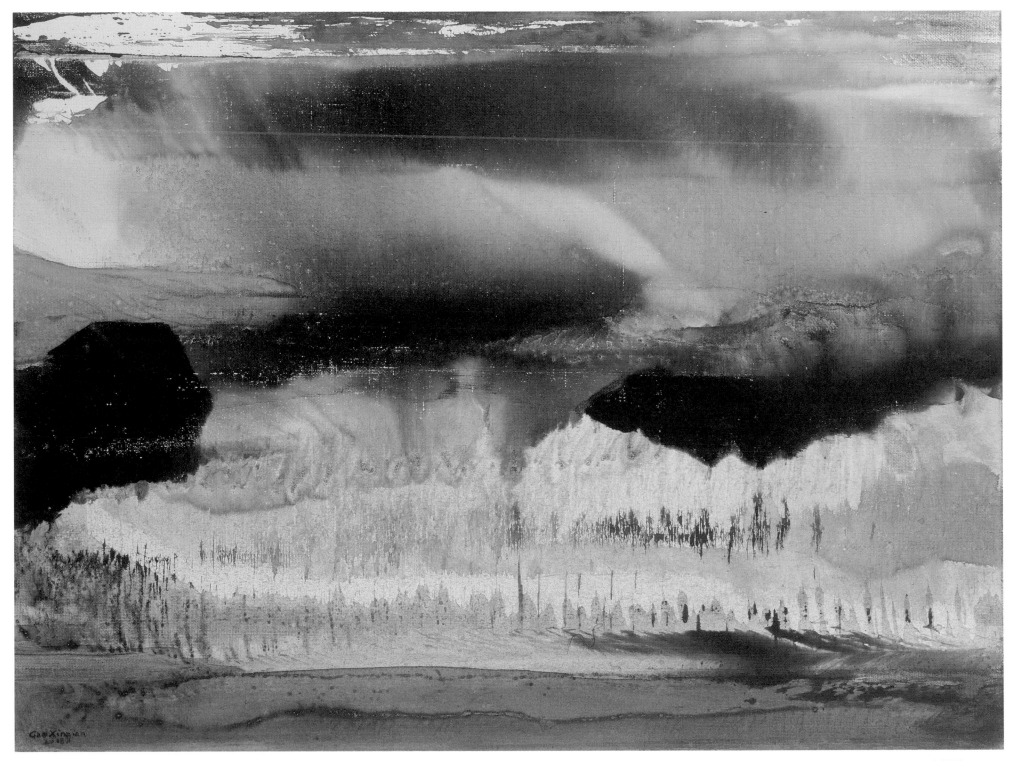

天與地，2008
Sky and Earth, 2008
Ink in Canvas, 54 cm x 73 cm

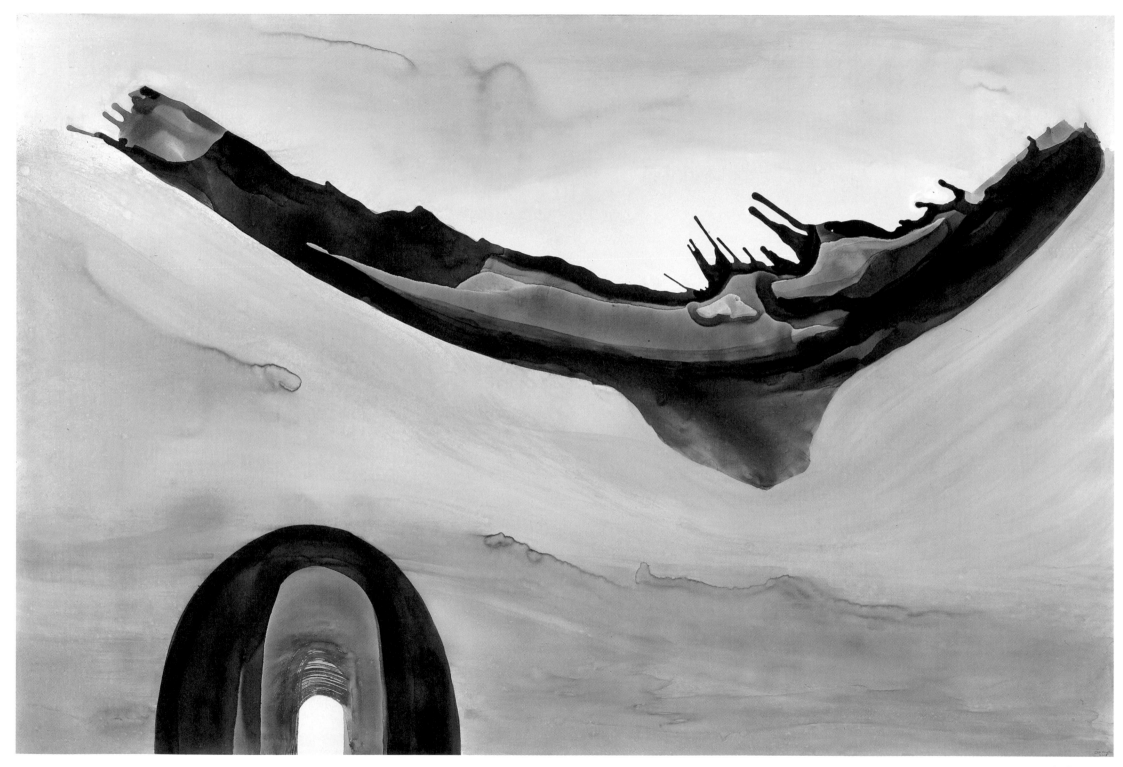

發生，2006
Take place, 2006
Ink in Canvas, 200 cm x 300 cm

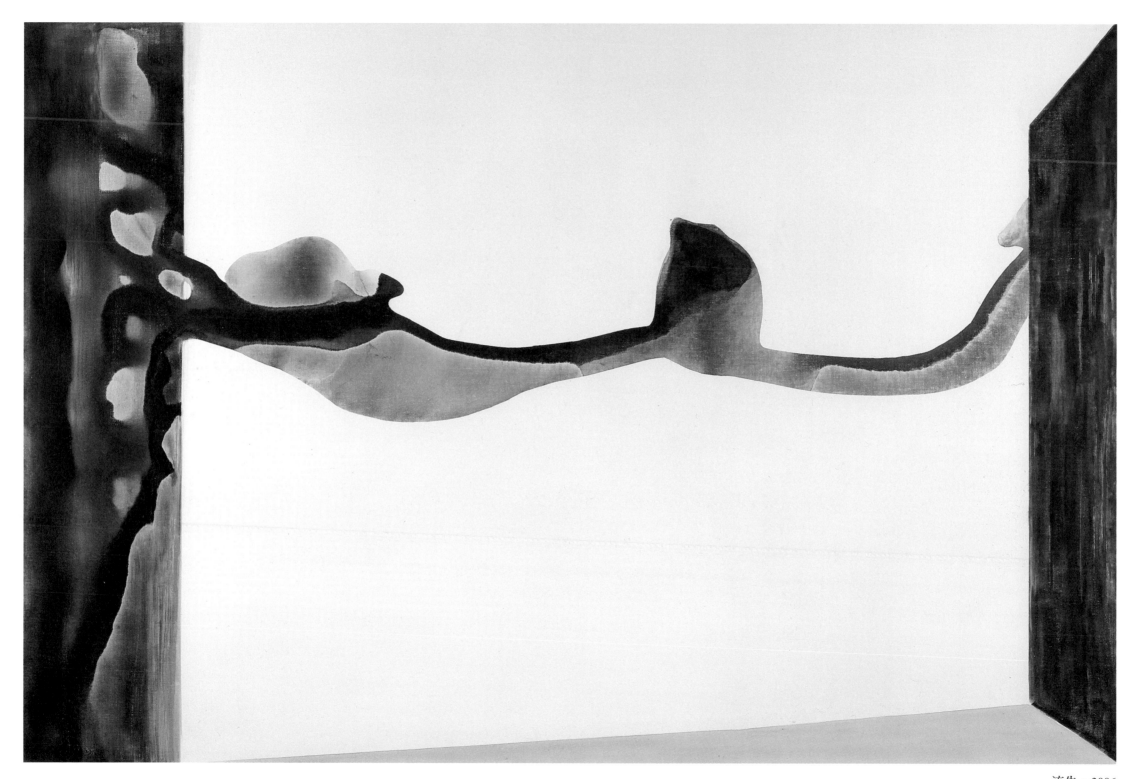

流失，2006
Outflow, 2006
Ink in Canvas, 200 cm x 300 cm

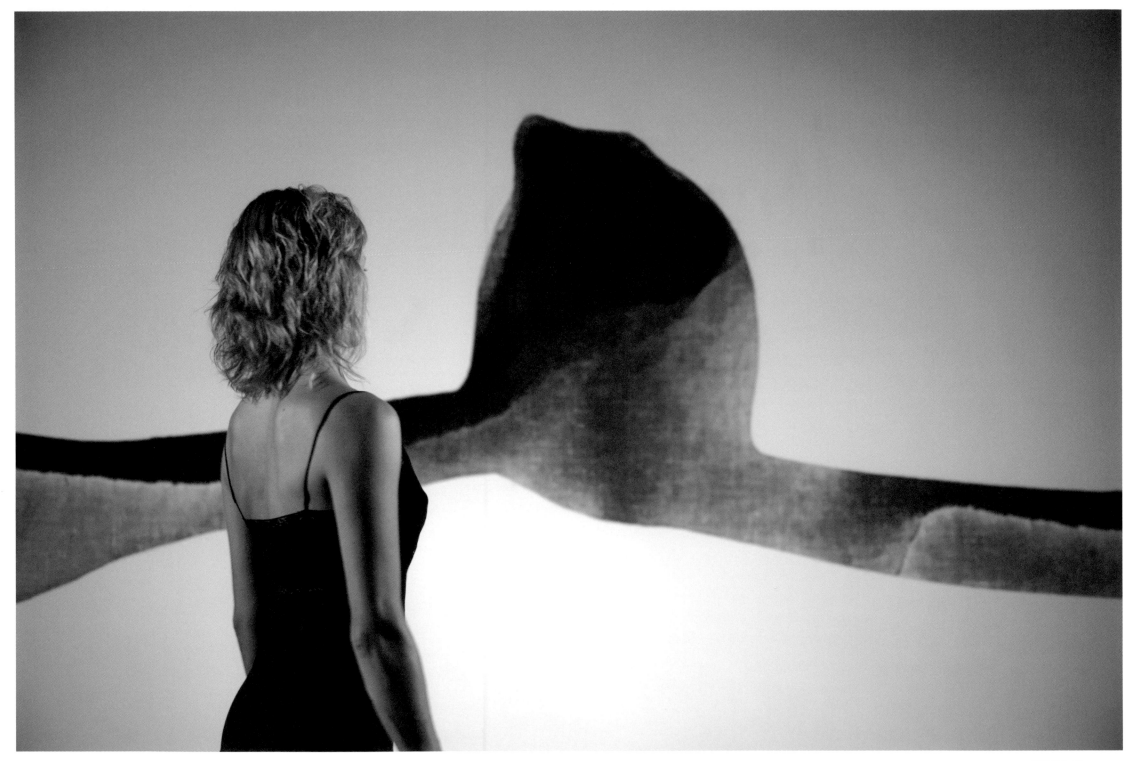

洪荒之後，2008
After the Flood, 2008

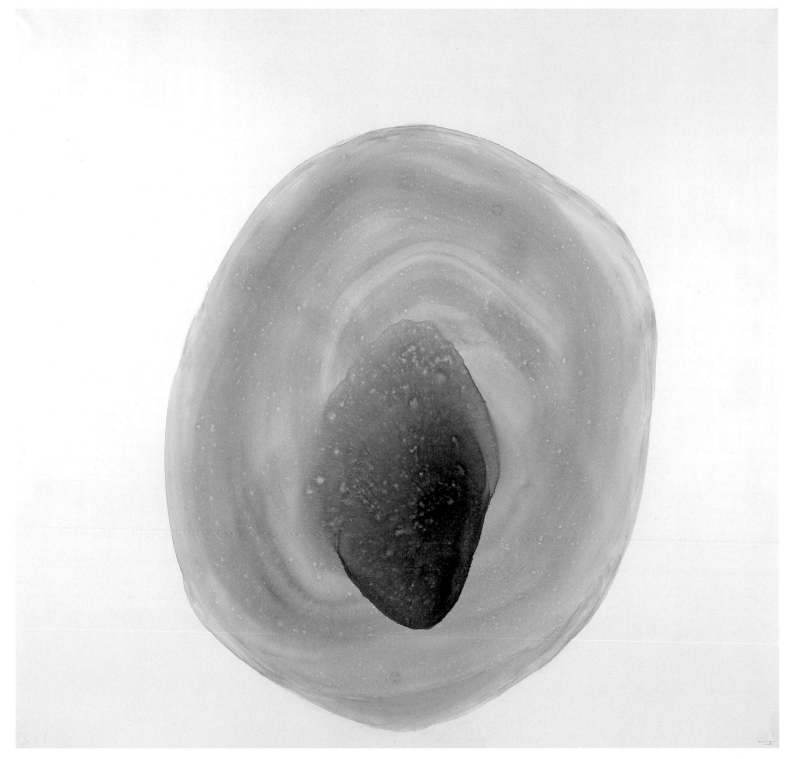

吸・2006
Absorption, 2006
Ink in Canvas, 192 cm x 200 cm

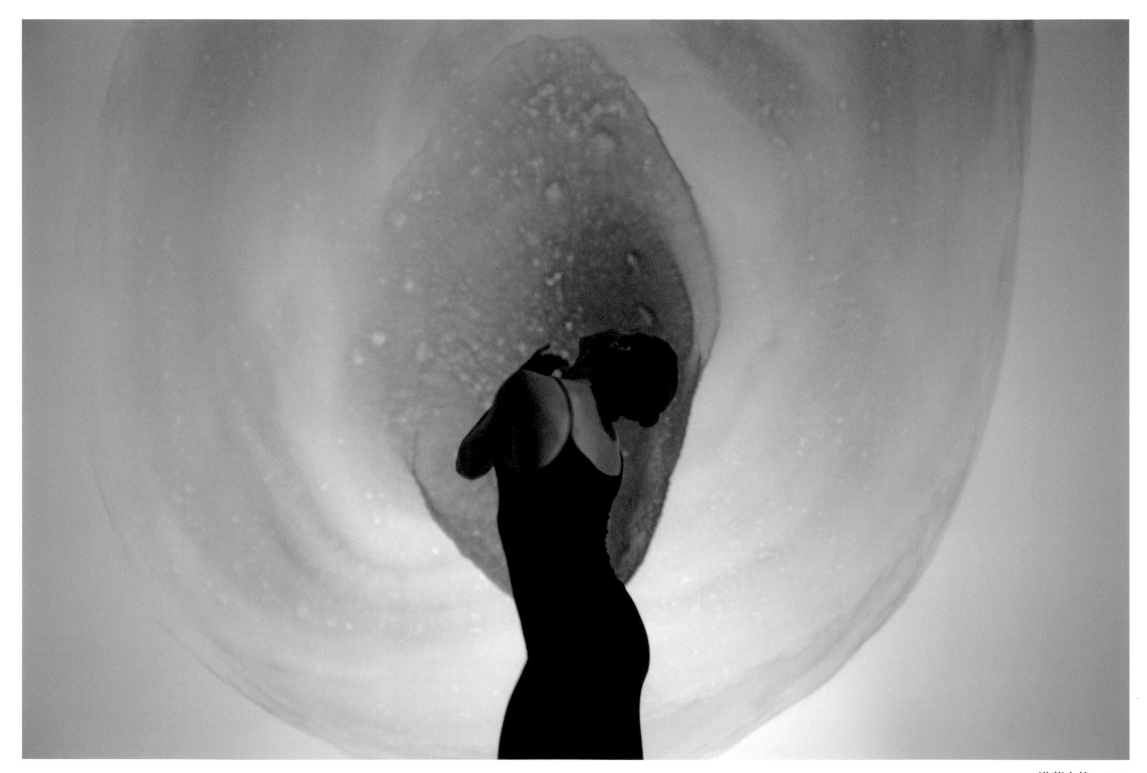

洪荒之後，2008
After the Flood, 2008

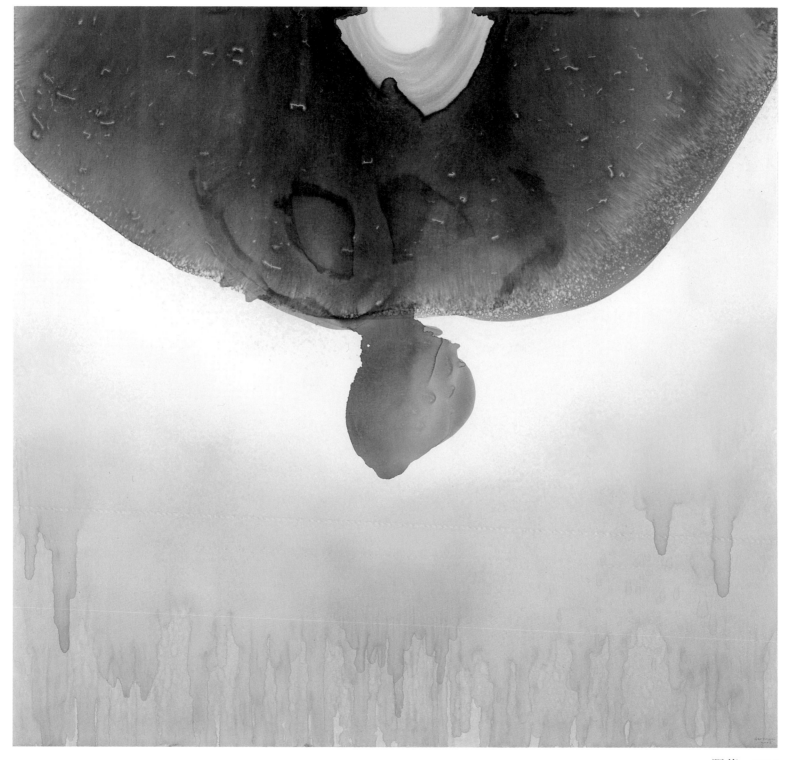

隕落，2006
The Fall, 2006
Ink in Canvas, 192 cm x 200 cm

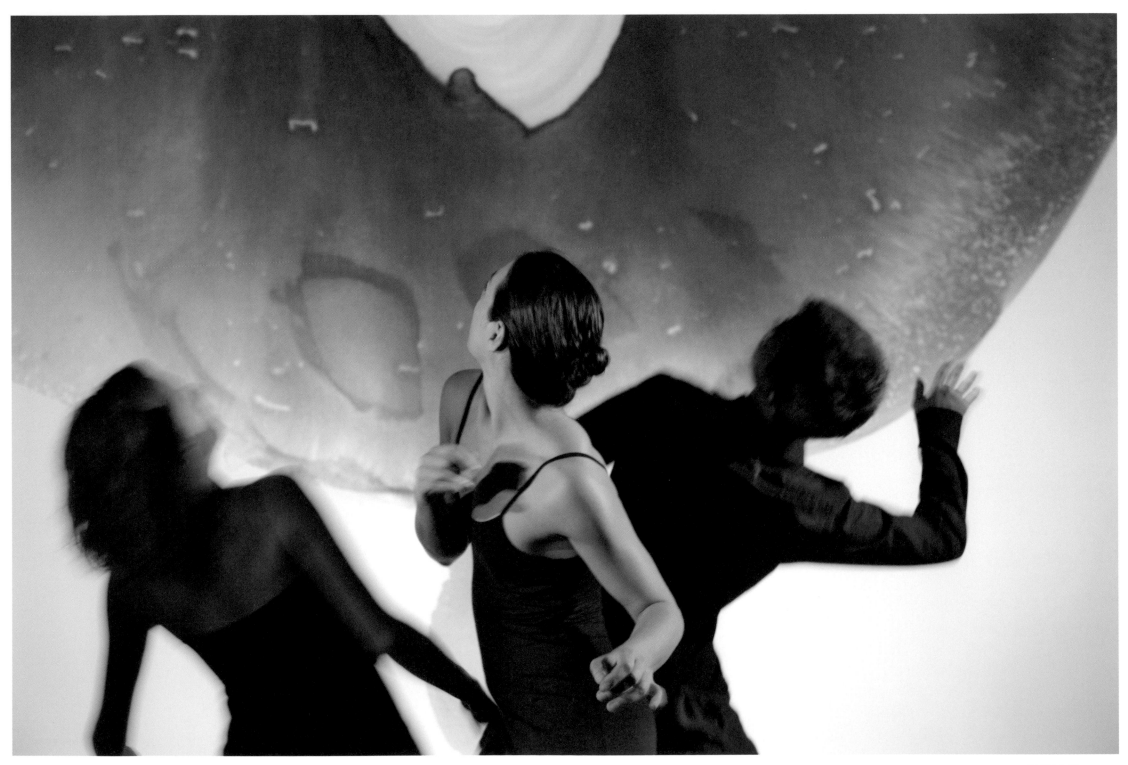

洪荒之後，2008
After the Flood, 2008

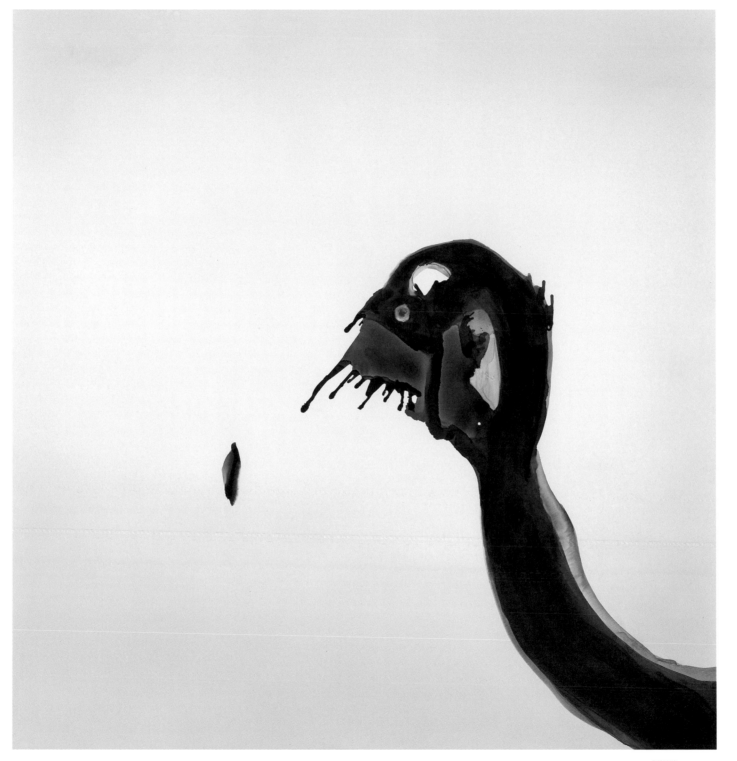

變異，2006
Alienation, 2006
Ink in Canvas, 200 cm x 192 cm

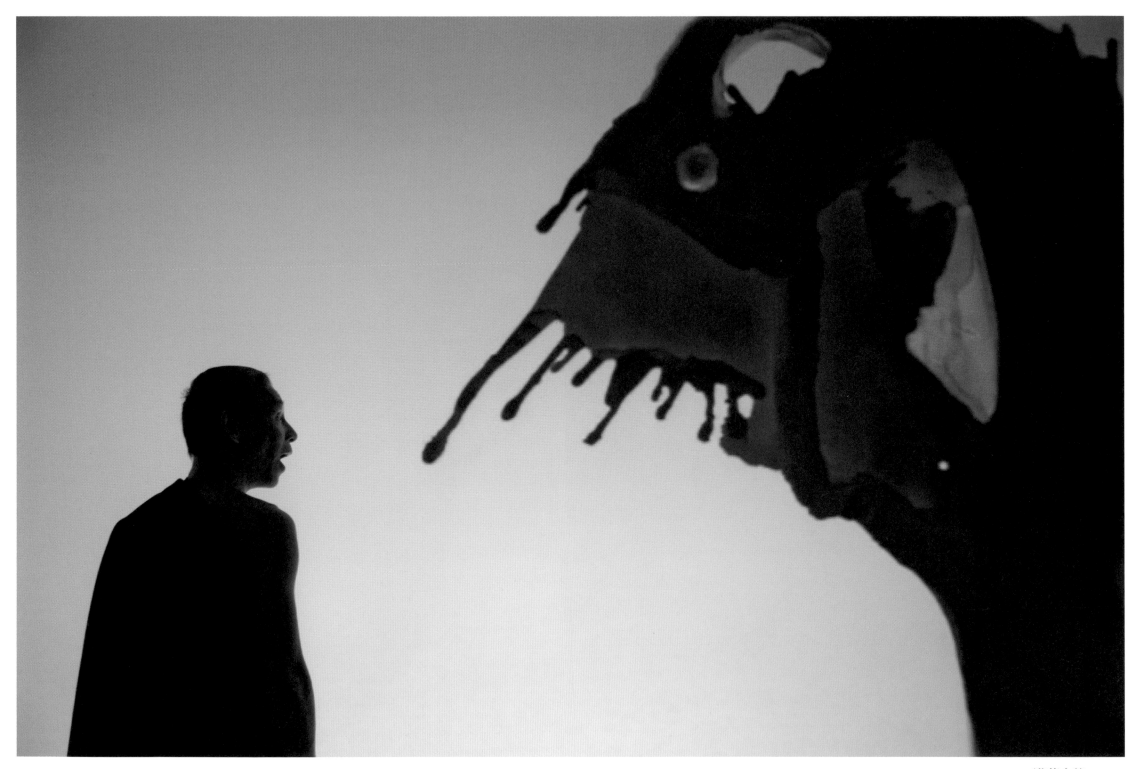

洪荒之後，2008
After the Flood, 2008

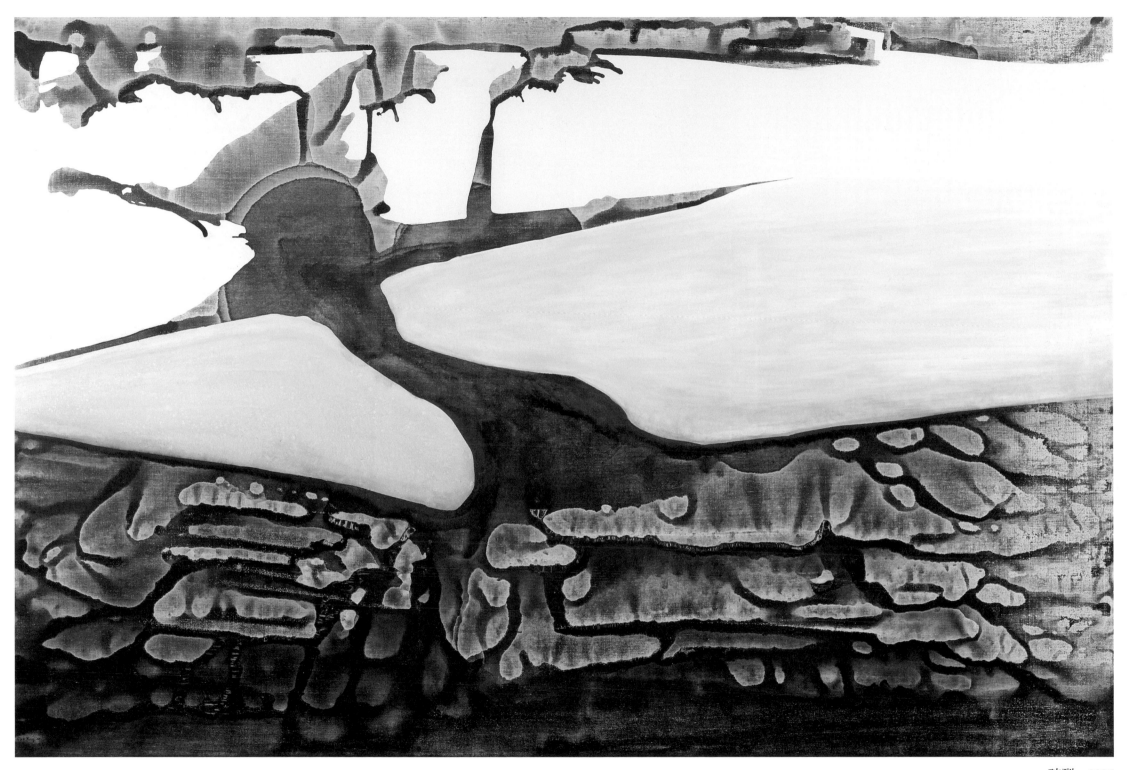

破裂，2006
Rupture, 2006
Ink in Canvas, 200 cm x 300 cm

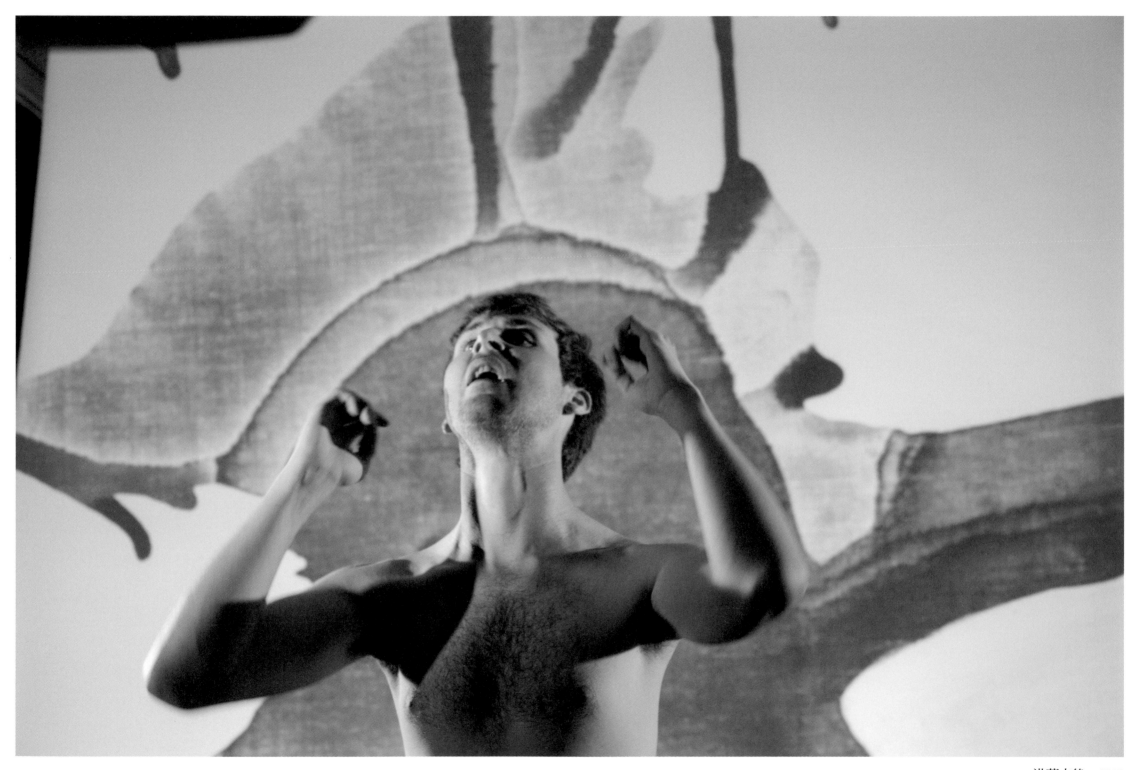

洪荒之後，2008
After the Flood, 2008

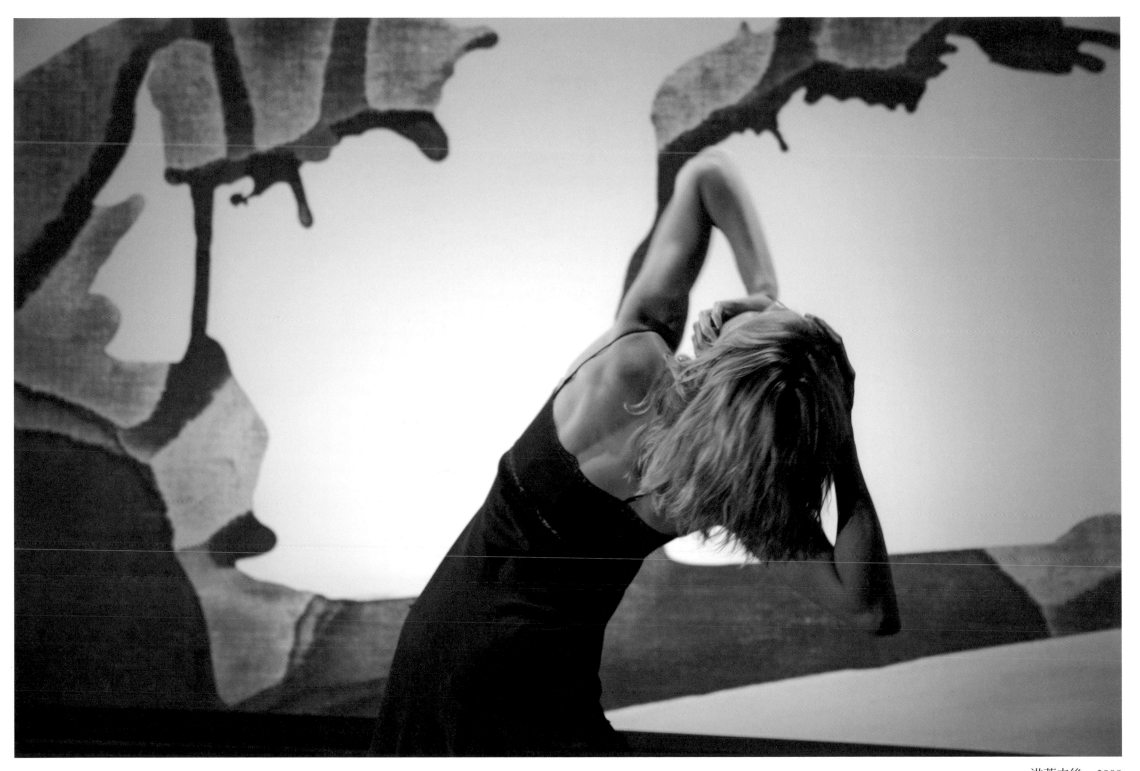

洪荒之後，2008
After the Flood, 2008

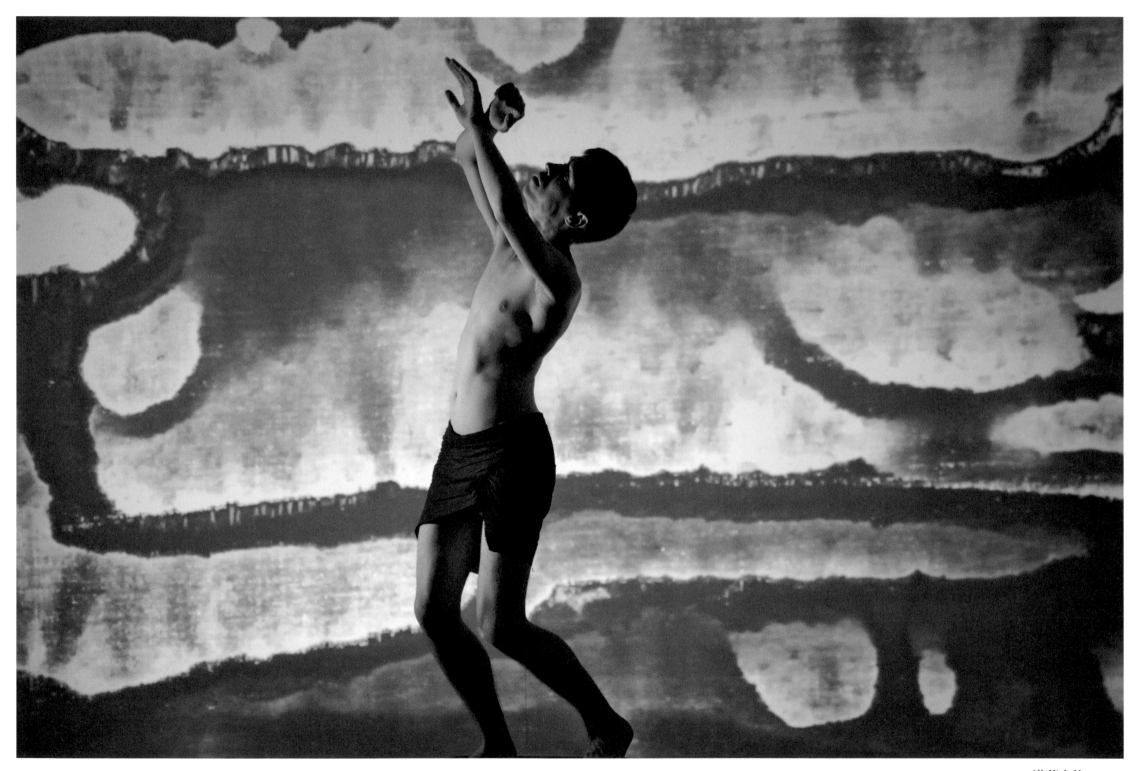

洪荒之後，2008
After the Flood, 2008

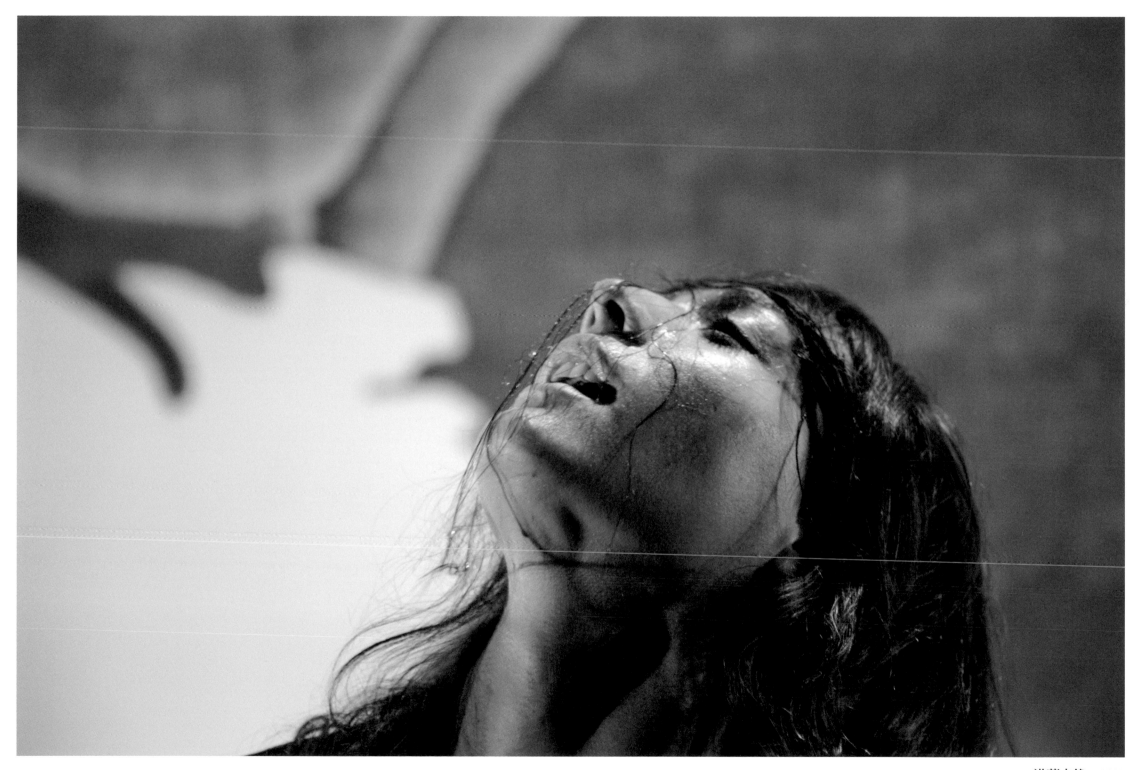

洪荒之後，2008
After the Flood, 2008

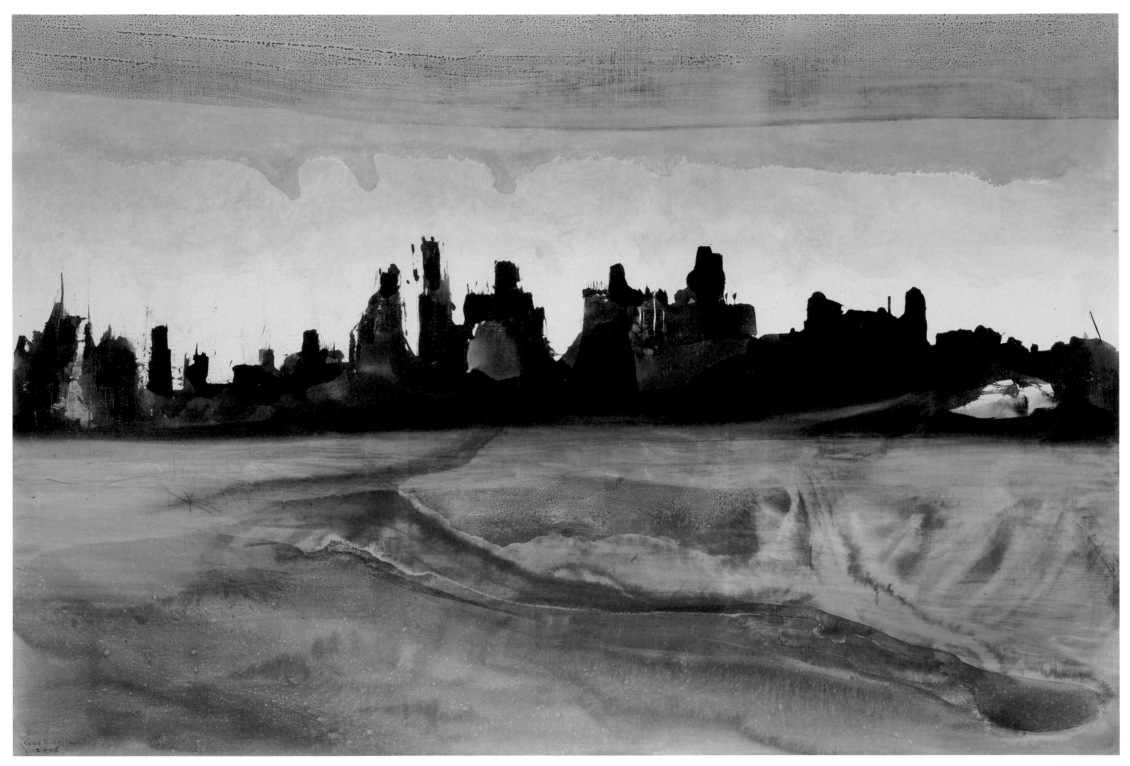

陷落・2008
Collapse, 2008
Ink in Canvas, 130 cm x 195 cm

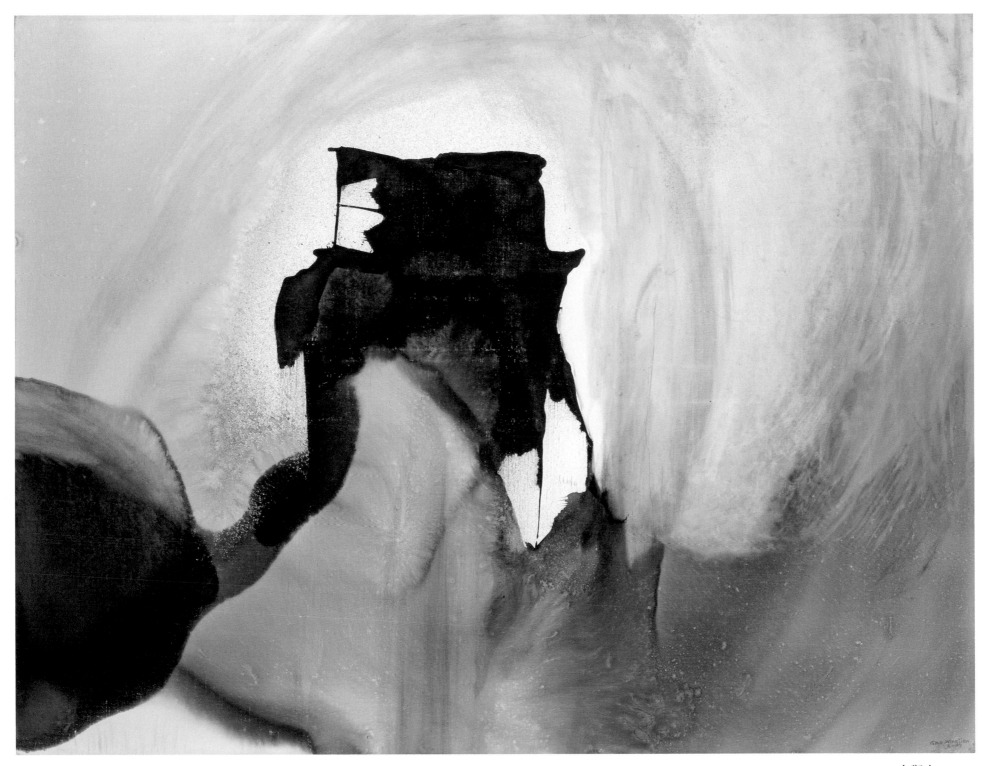

水與火，2007
Water and Fire, 2007
Ink in Canvas, 69 cm x 116 cm

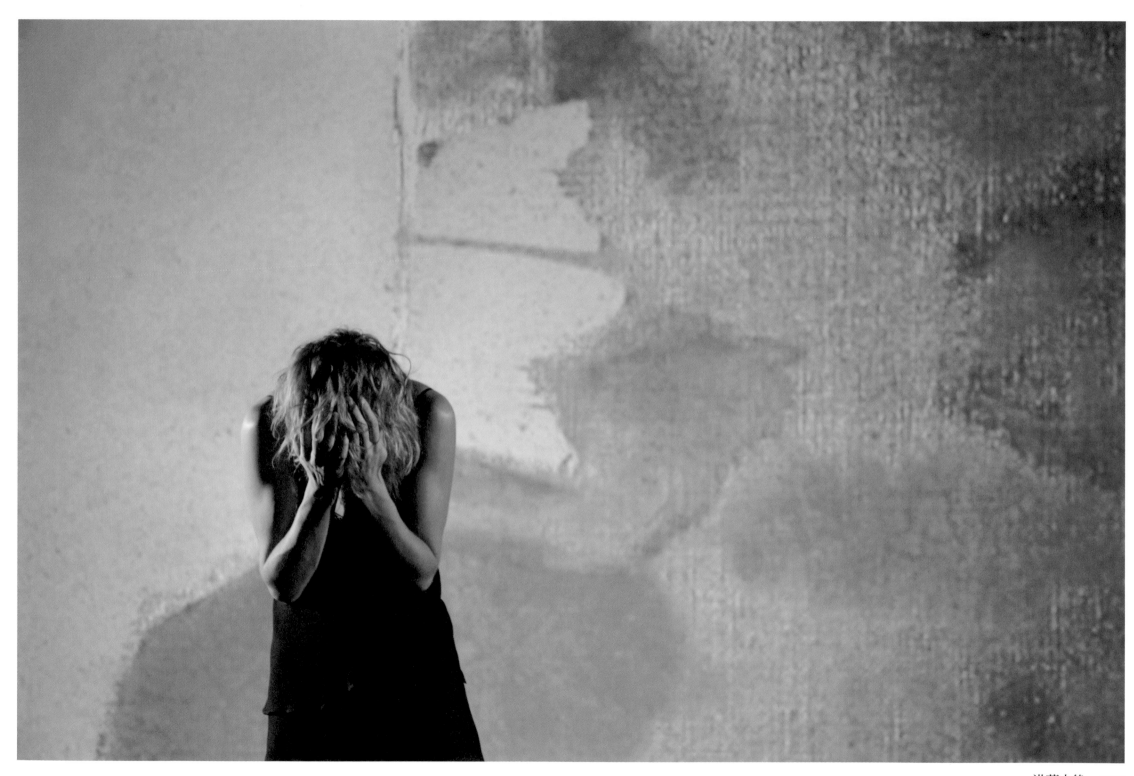

洪荒之後，2008
After the Flood, 2008

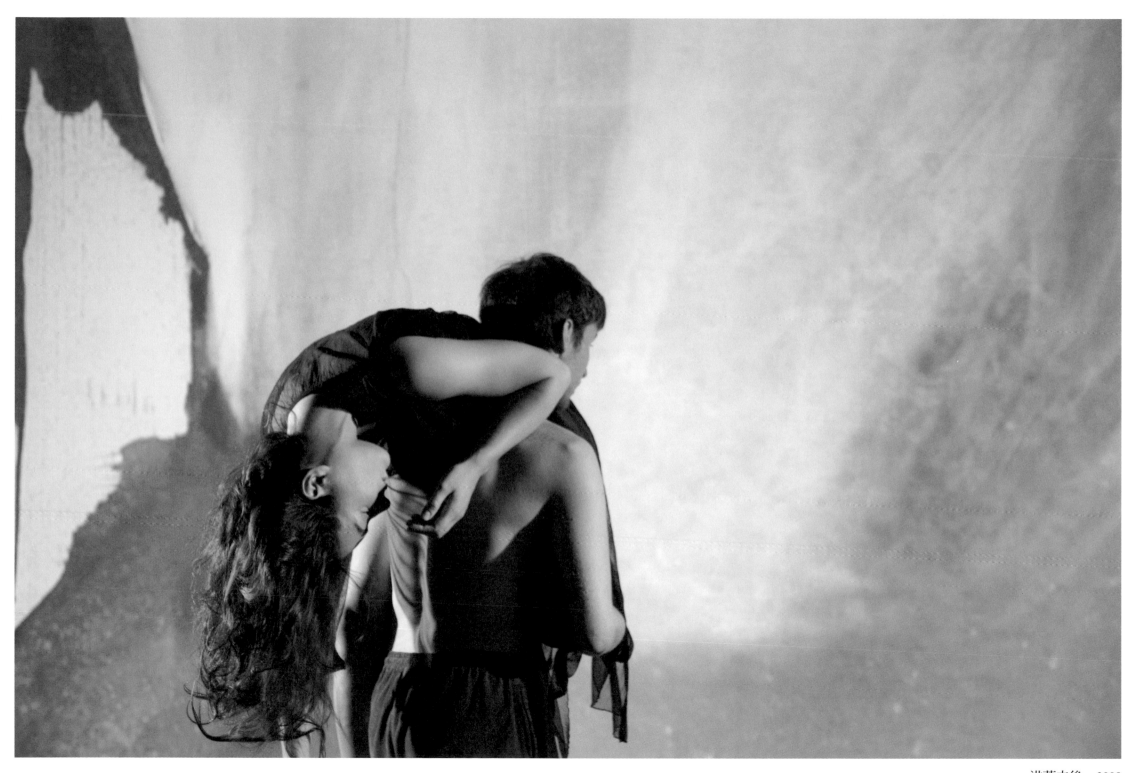

洪荒之後，2008
After the Flood, 2008

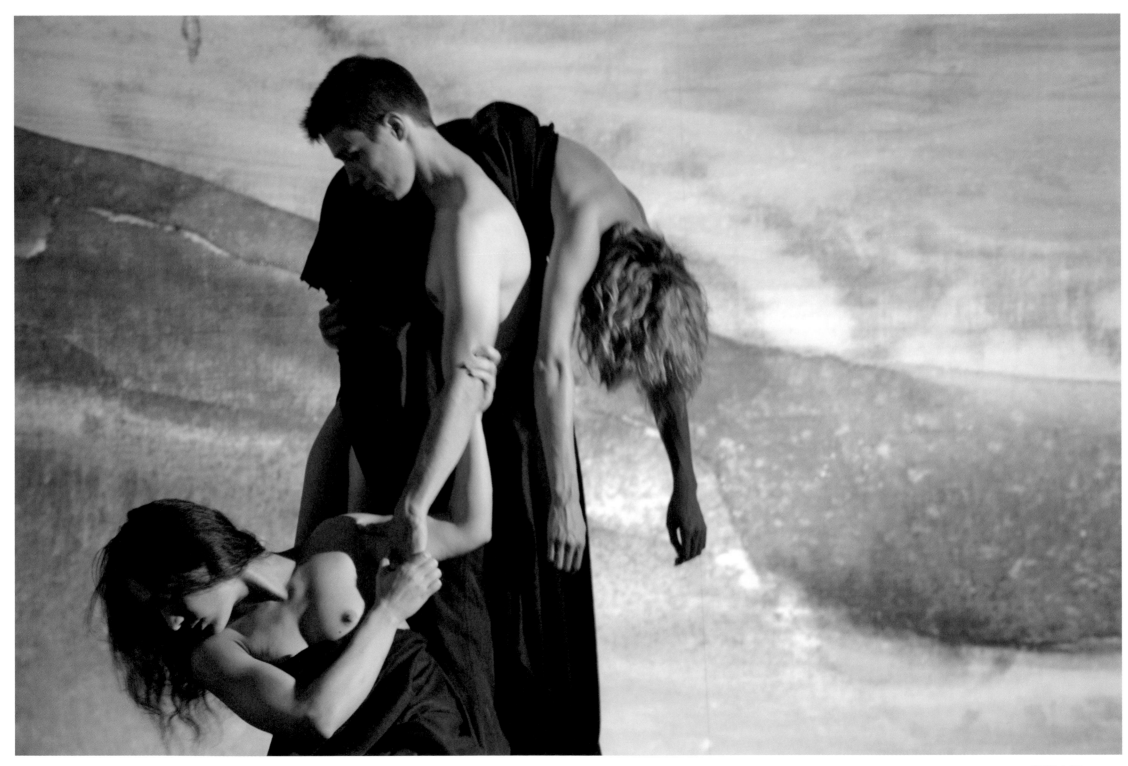

洪荒之後，2008
After the Flood, 2008

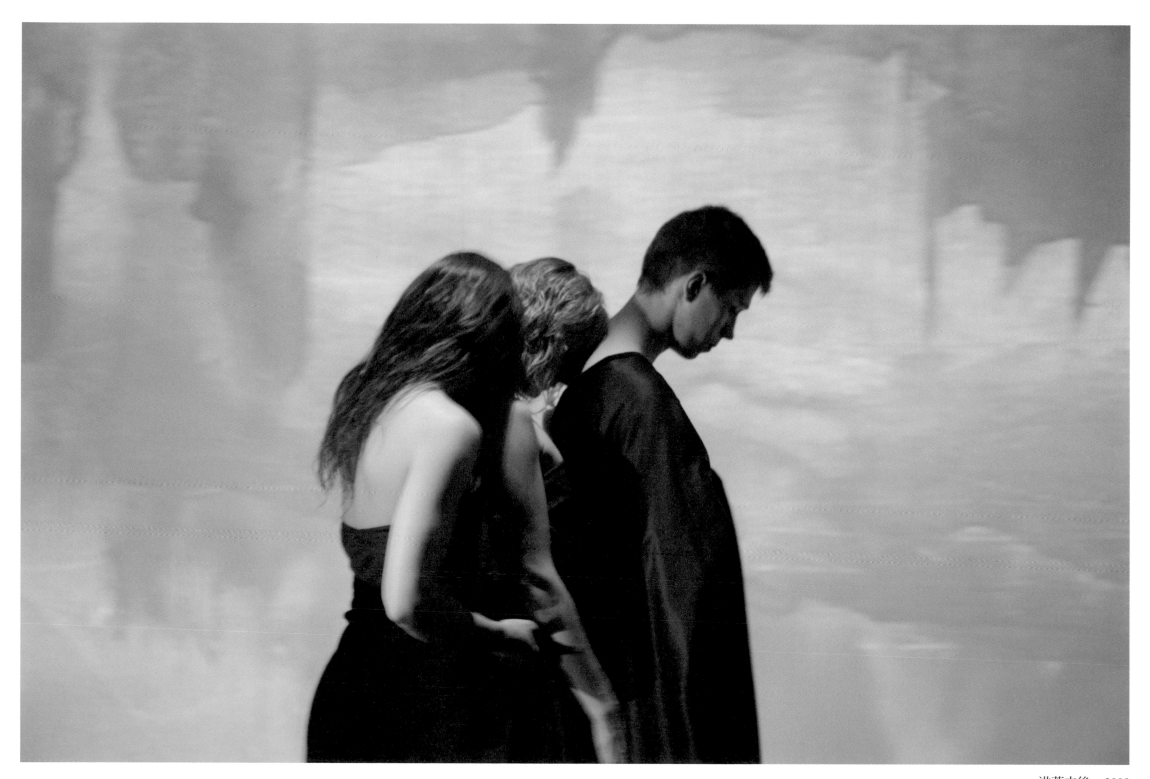

洪荒之後，2008
After the Flood, 2008

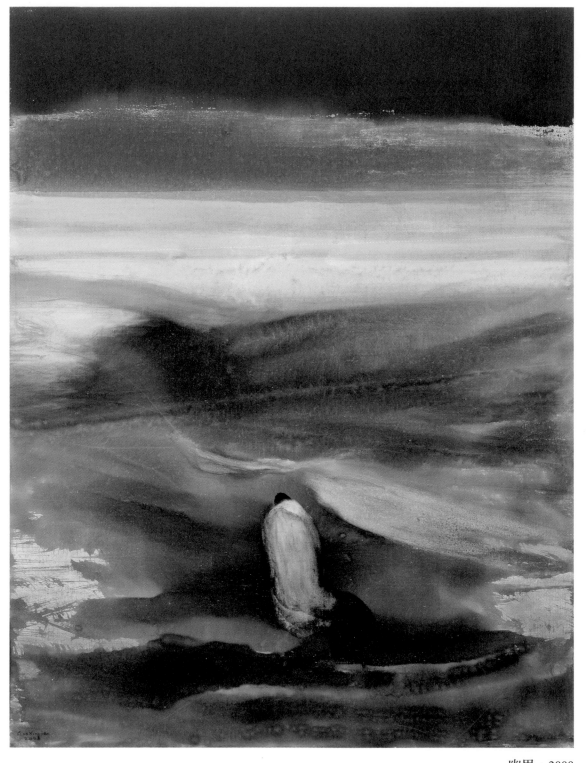

幽思，2008
Meditation, 2008
Ink in Canvas, 116 cm x 89 cm

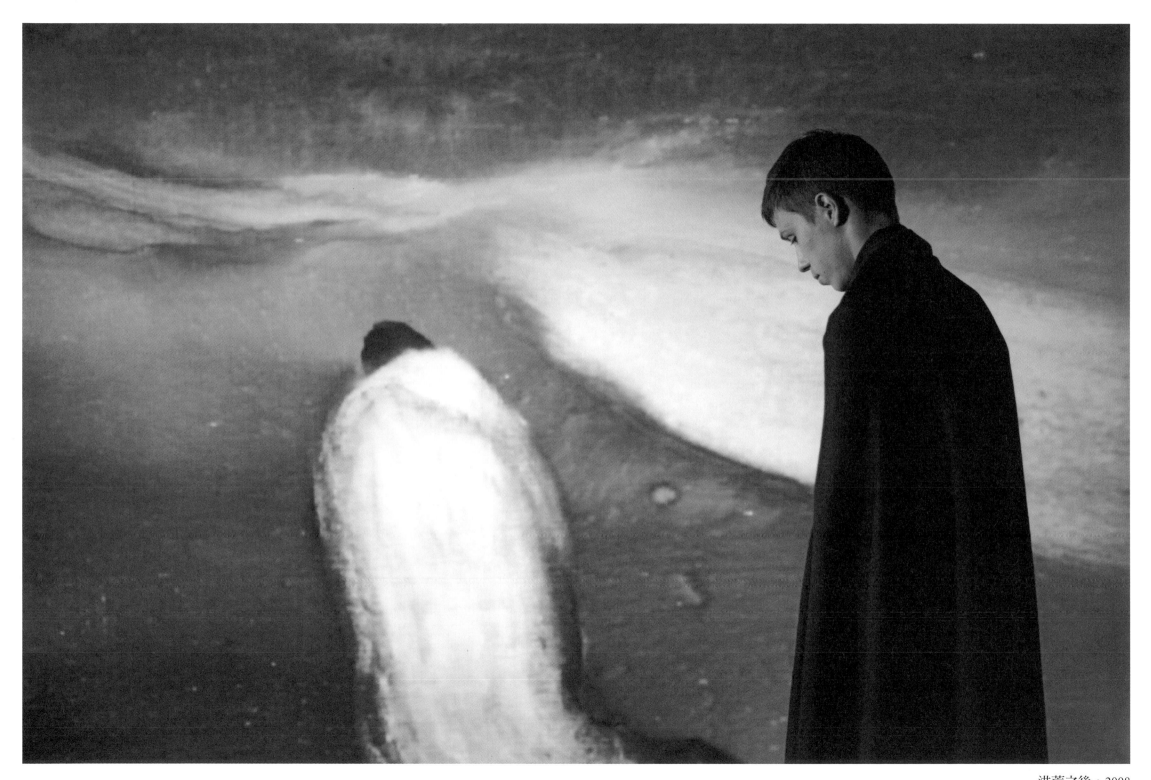

洪荒之後，2008
After the Flood, 2008

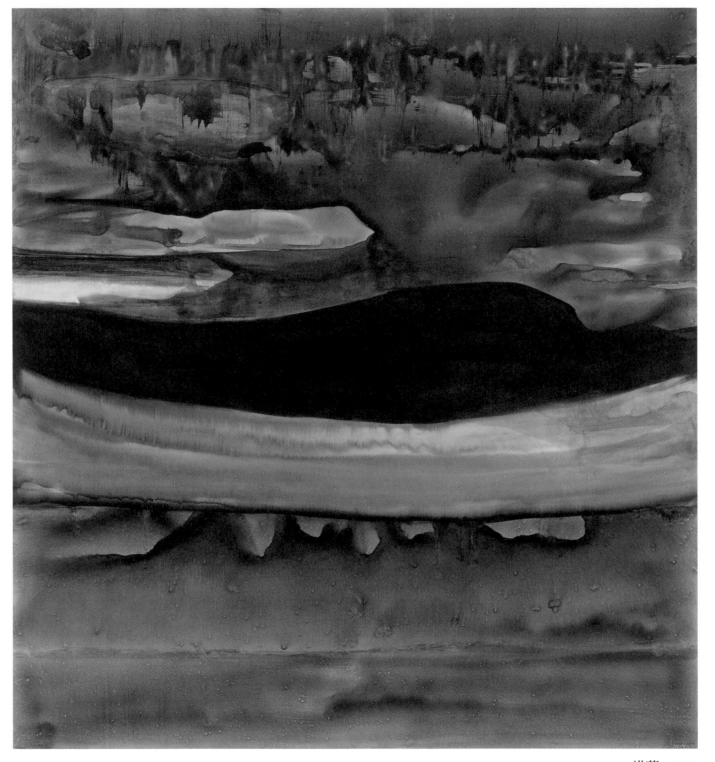

洪荒，2007
The Flood, 2007
Ink in Canvas, 240 cm x 225 cm

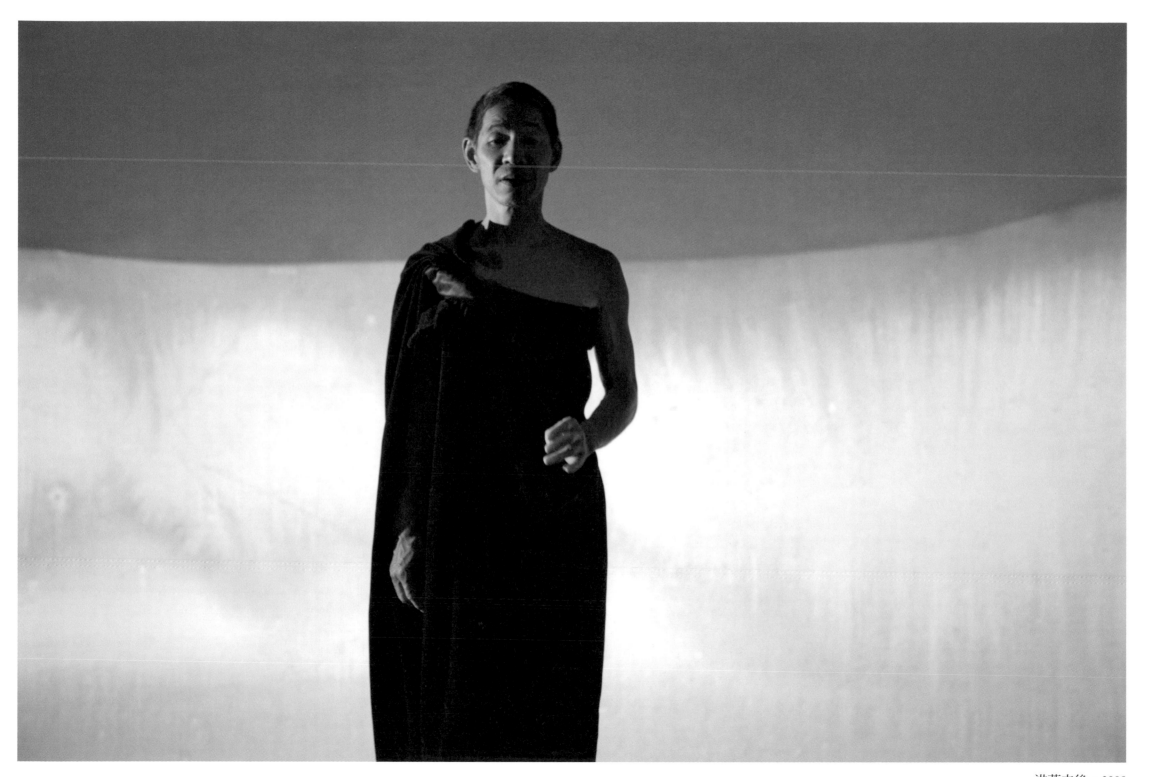

洪荒之後，2008
After the Flood, 2008

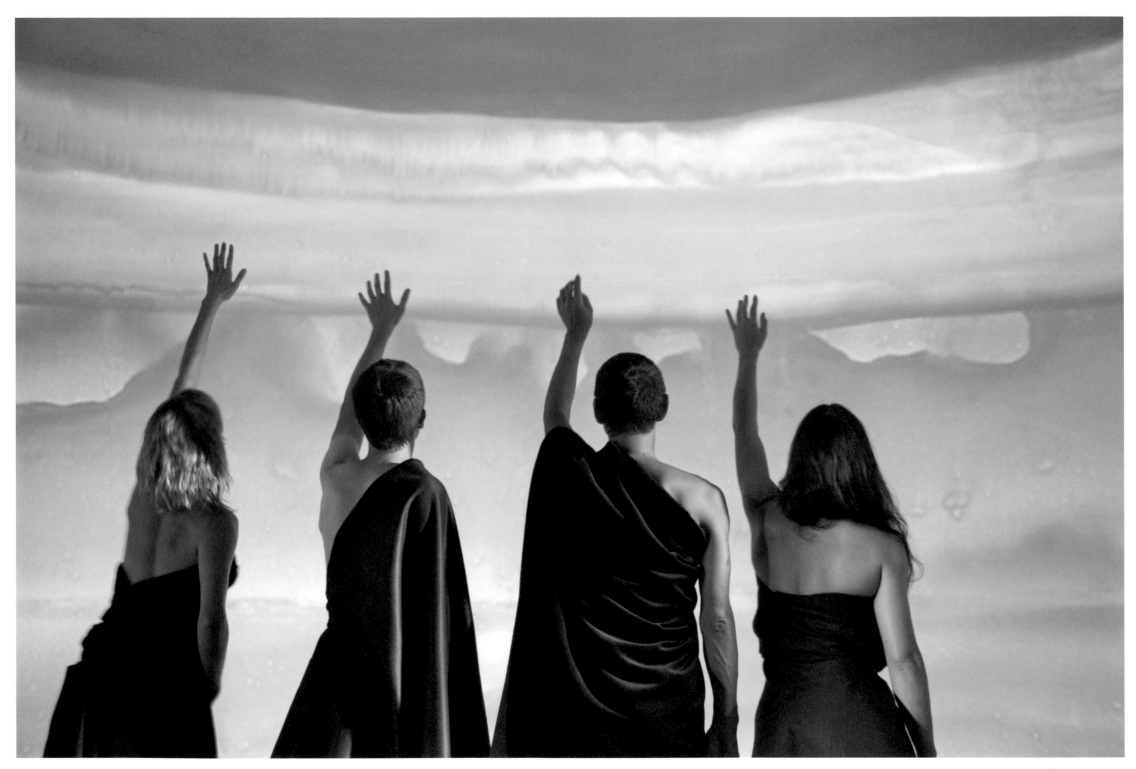

洪荒之後，2008
After the Flood, 2008

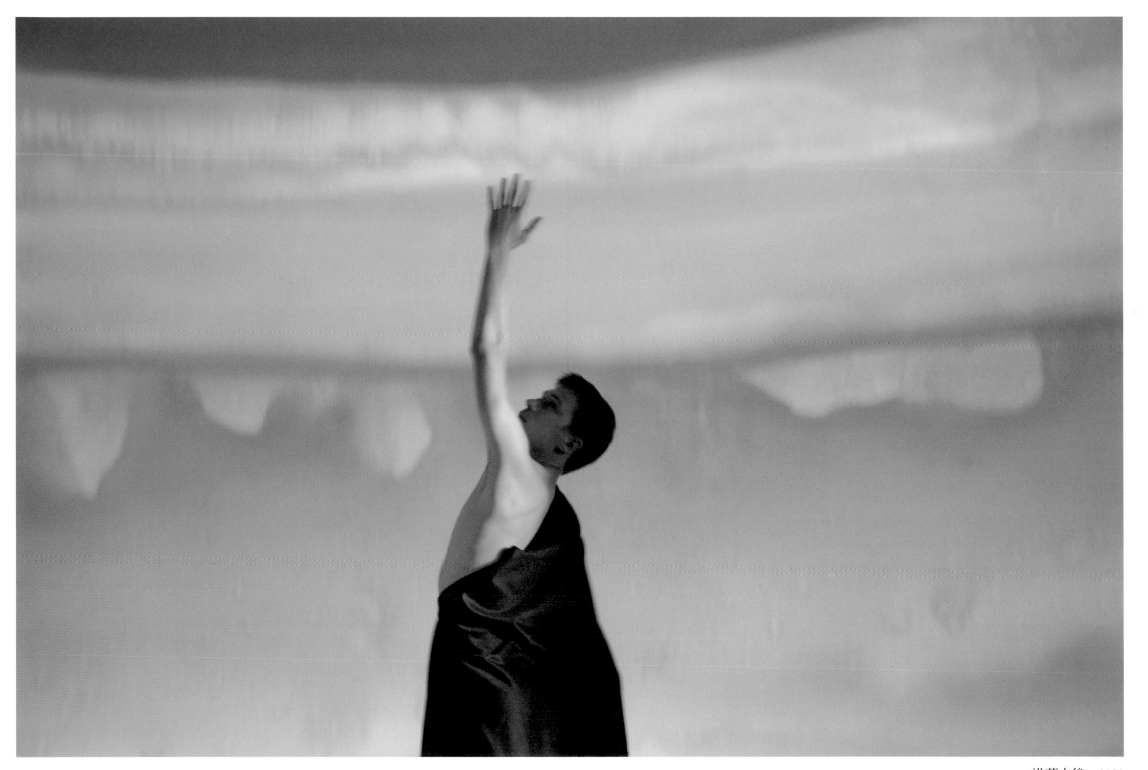

洪荒之後，2008
After the Flood, 2008

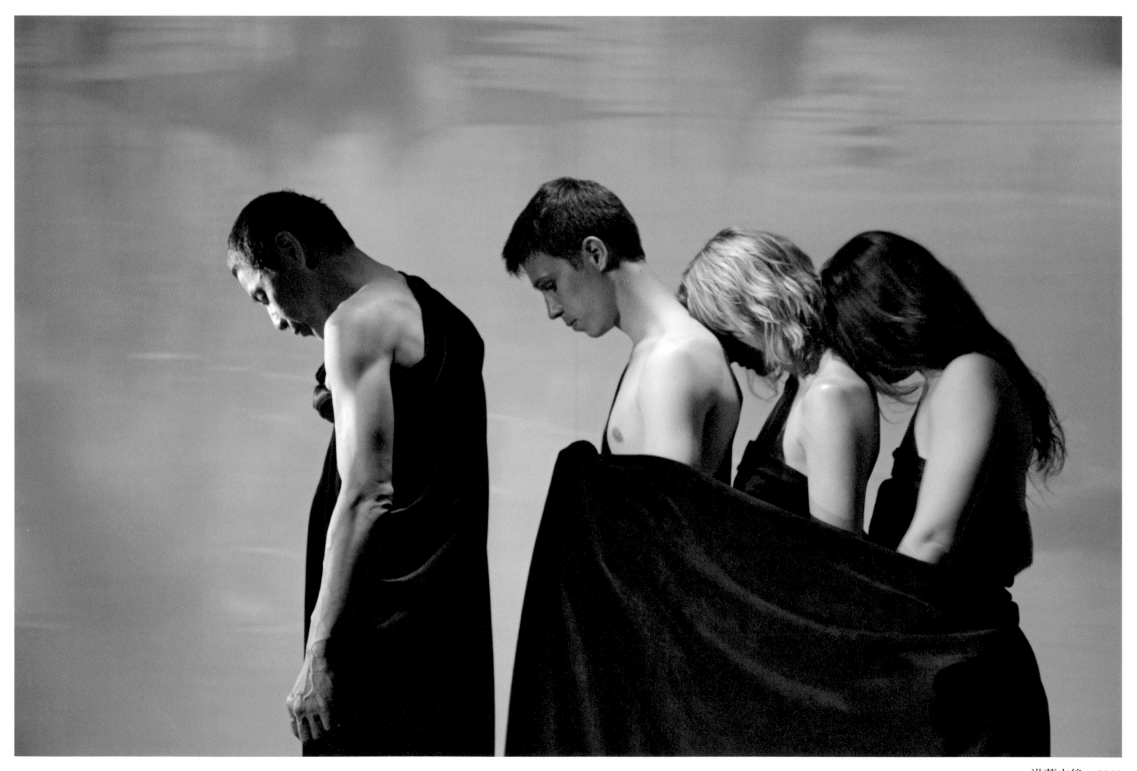

洪荒之後，2008
After the Flood, 2008

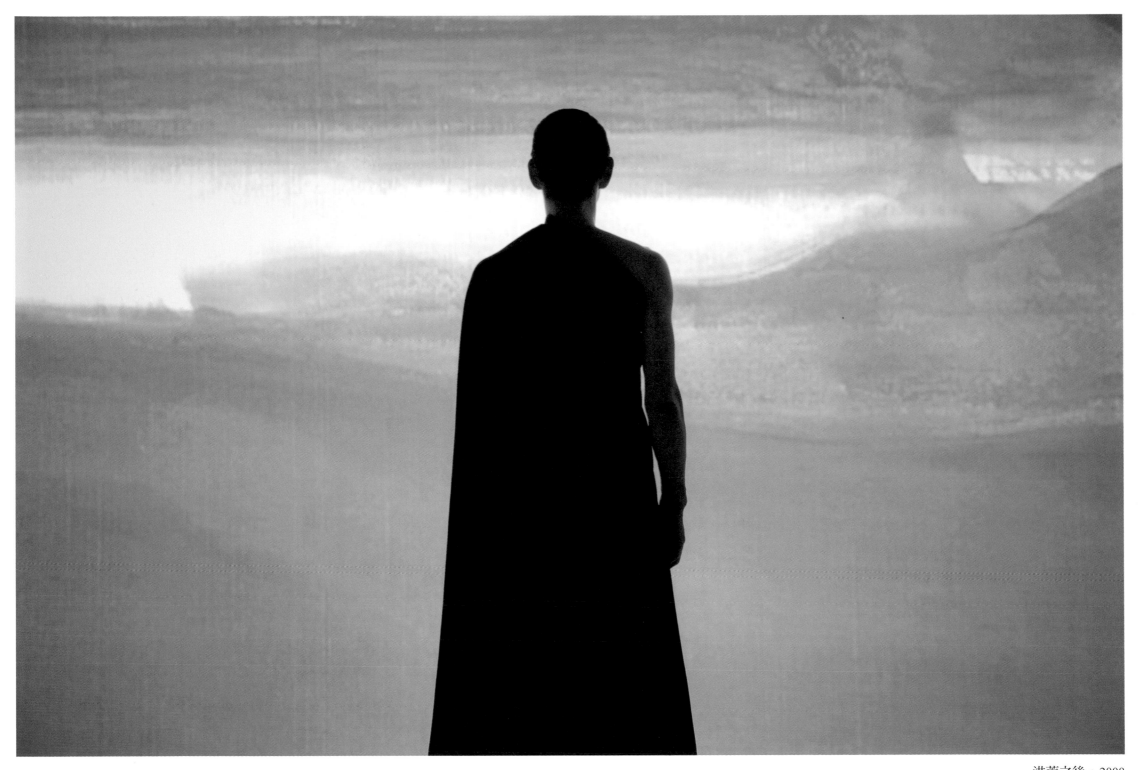

洪荒之後，2008
After the Flood, 2008

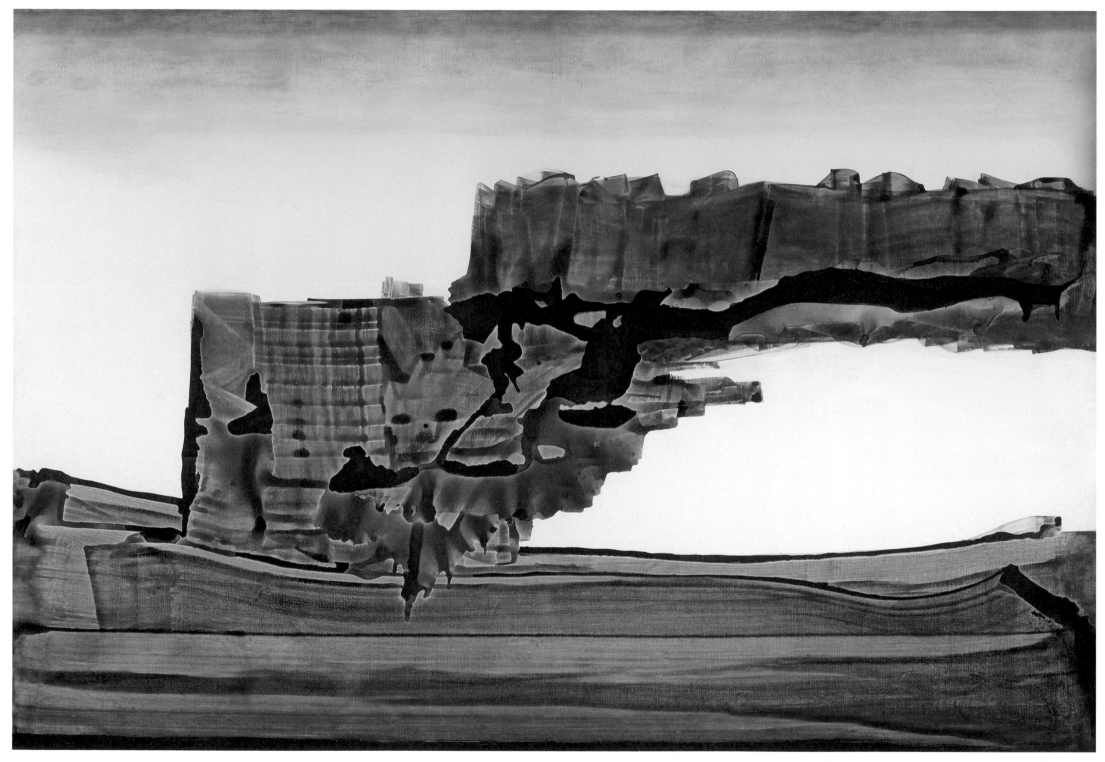

死城・2007
Dead City, 2007
Ink in Canvas, 240 cm x 350 cm

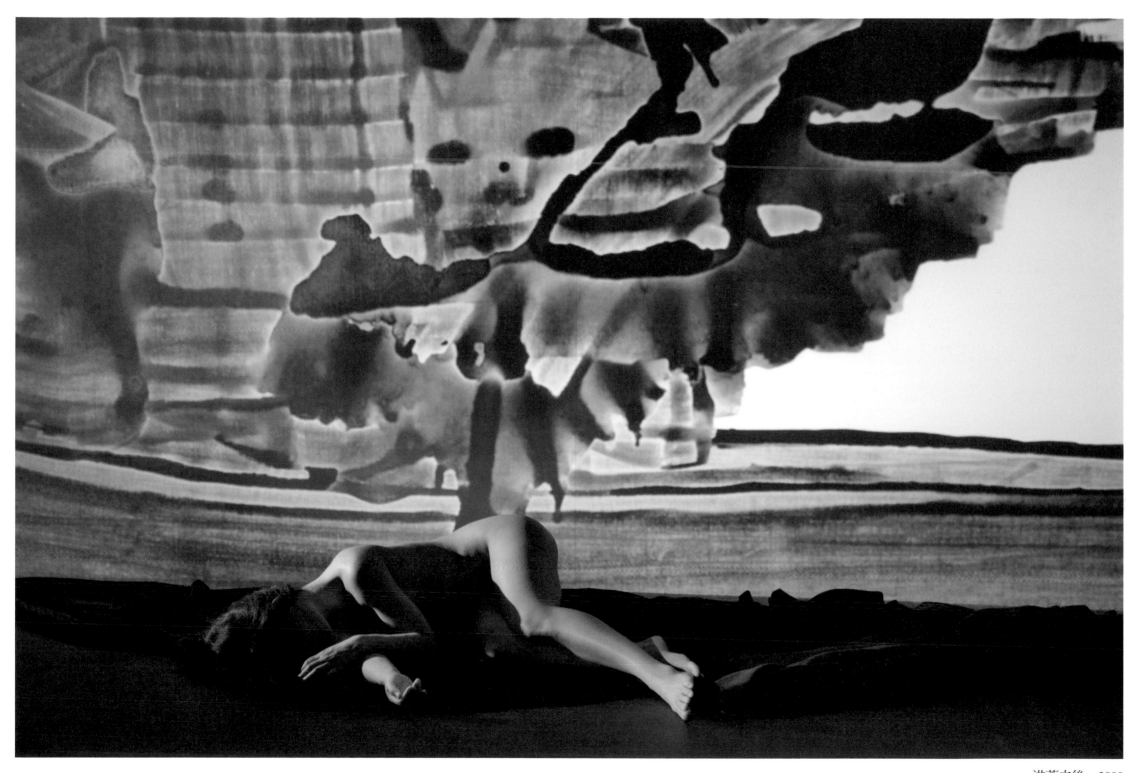

洪荒之後，2008
After the Flood, 2008

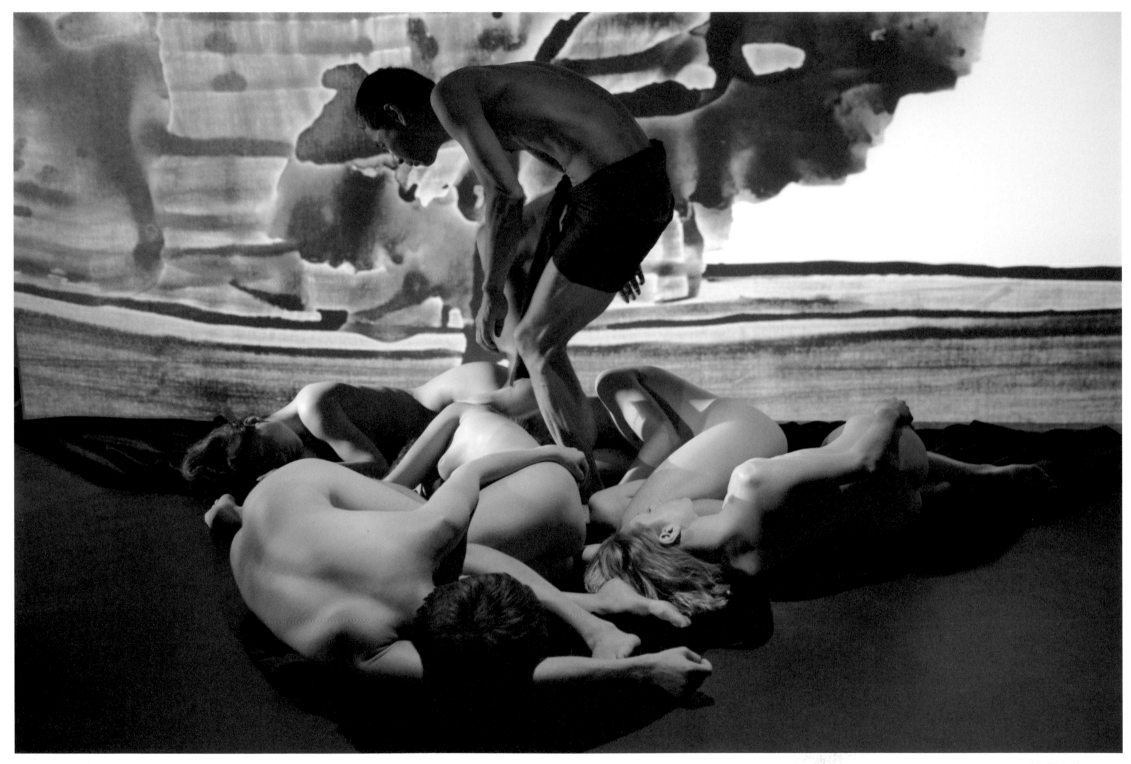

洪荒之後，2008
After the Flood, 2008

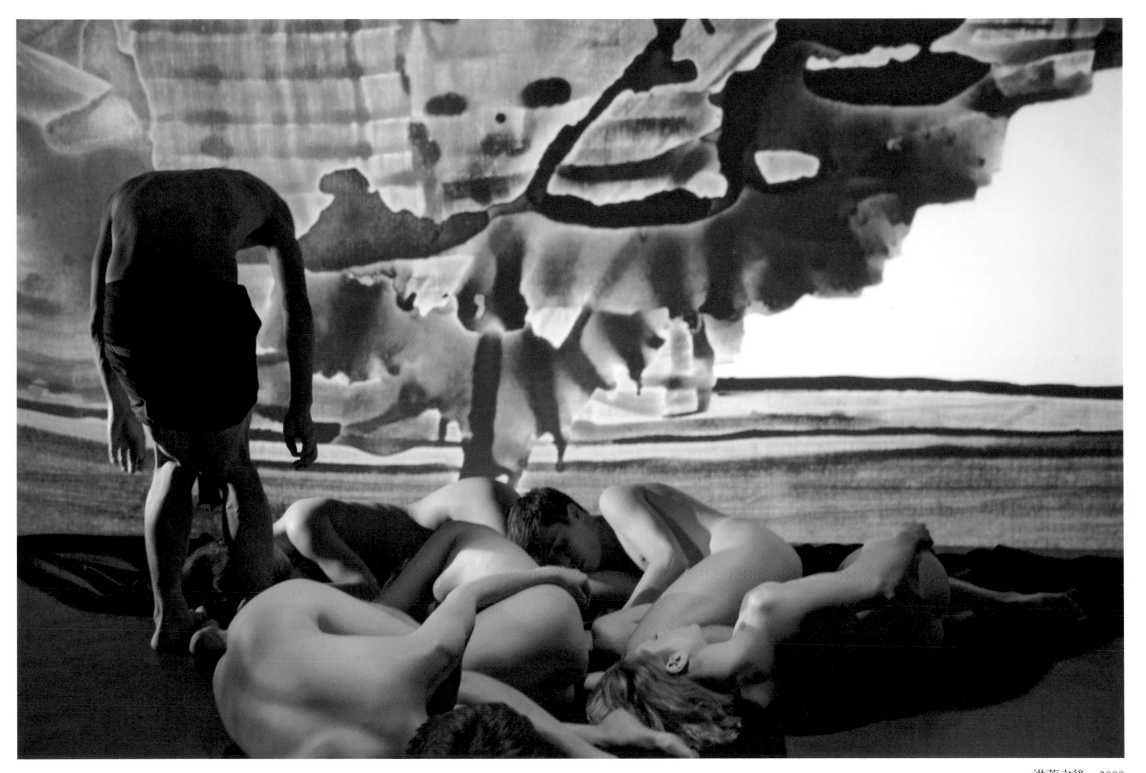

洪荒之後，2008
After the Flood, 2008

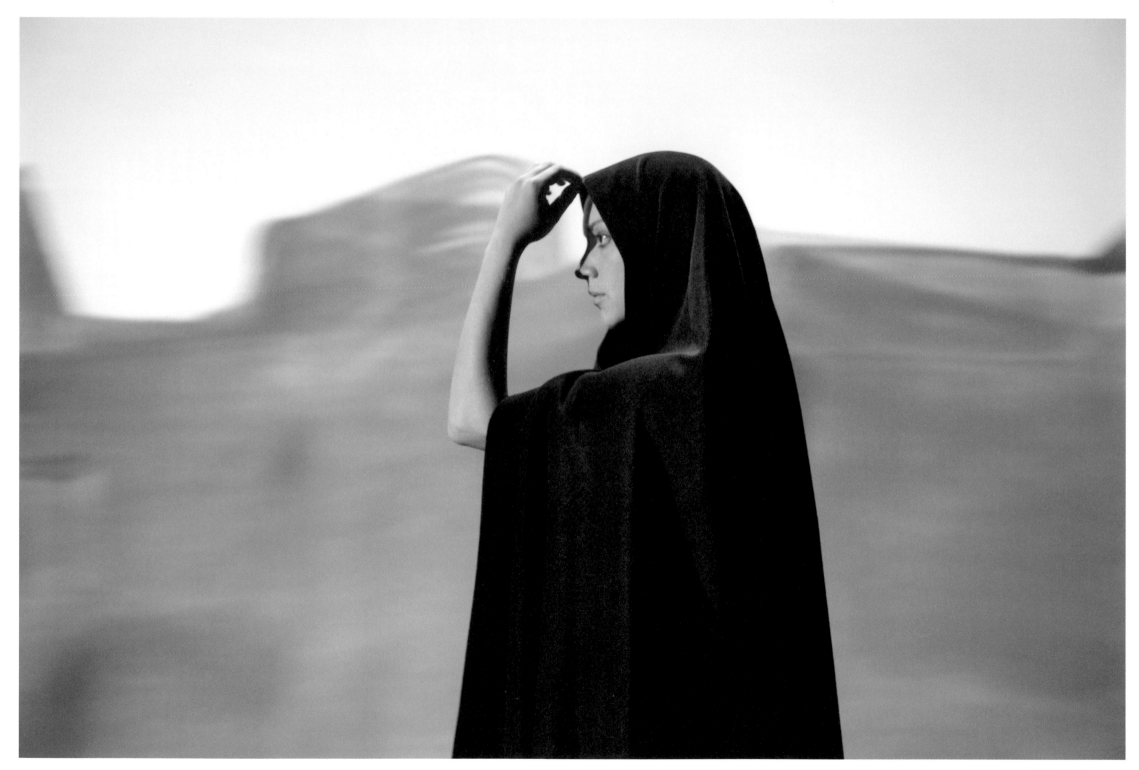

洪荒之後，2008
After the Flood, 2008

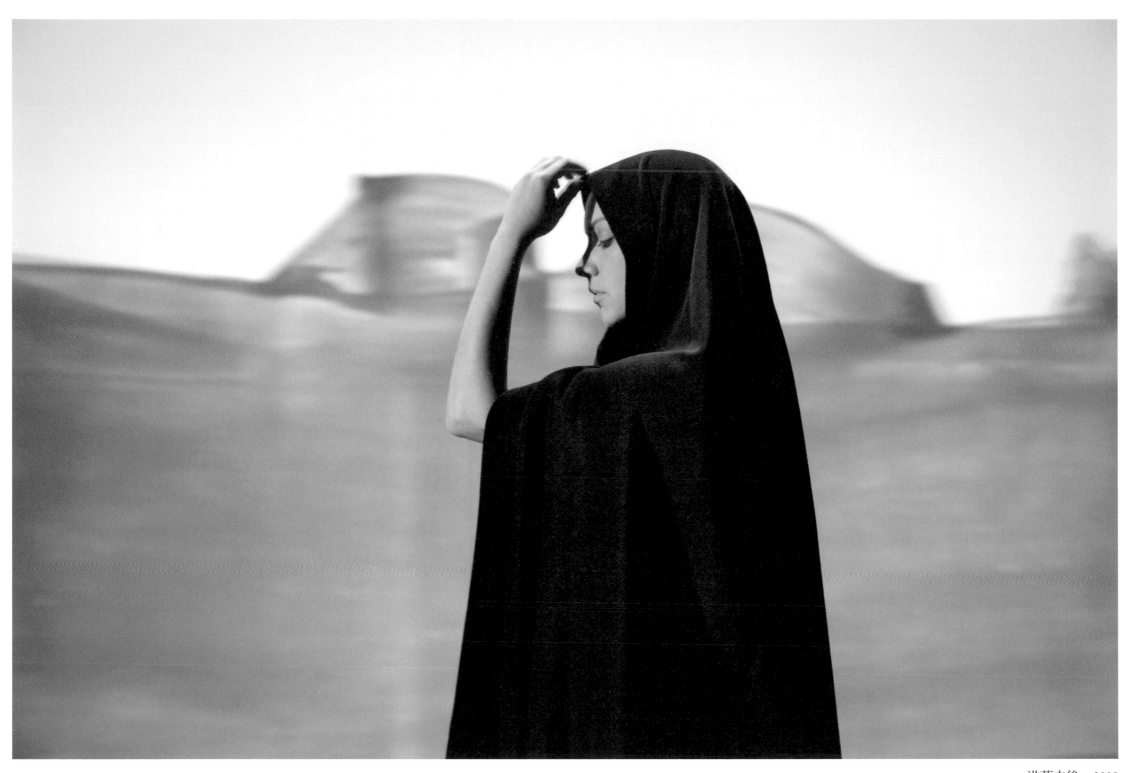

洪荒之後，2008
After the Flood, 2008

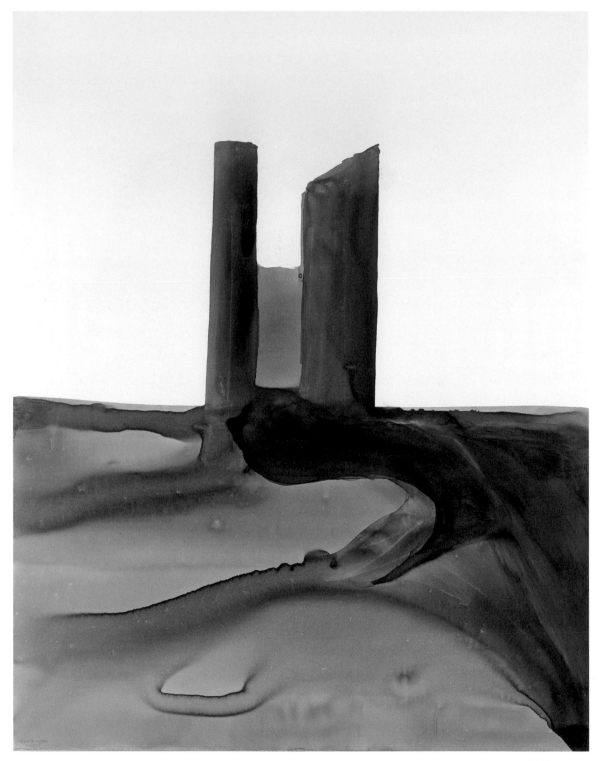

荒野，2007
Wilderness, 2007
Ink in Canvas, 145 cm x 114 cm

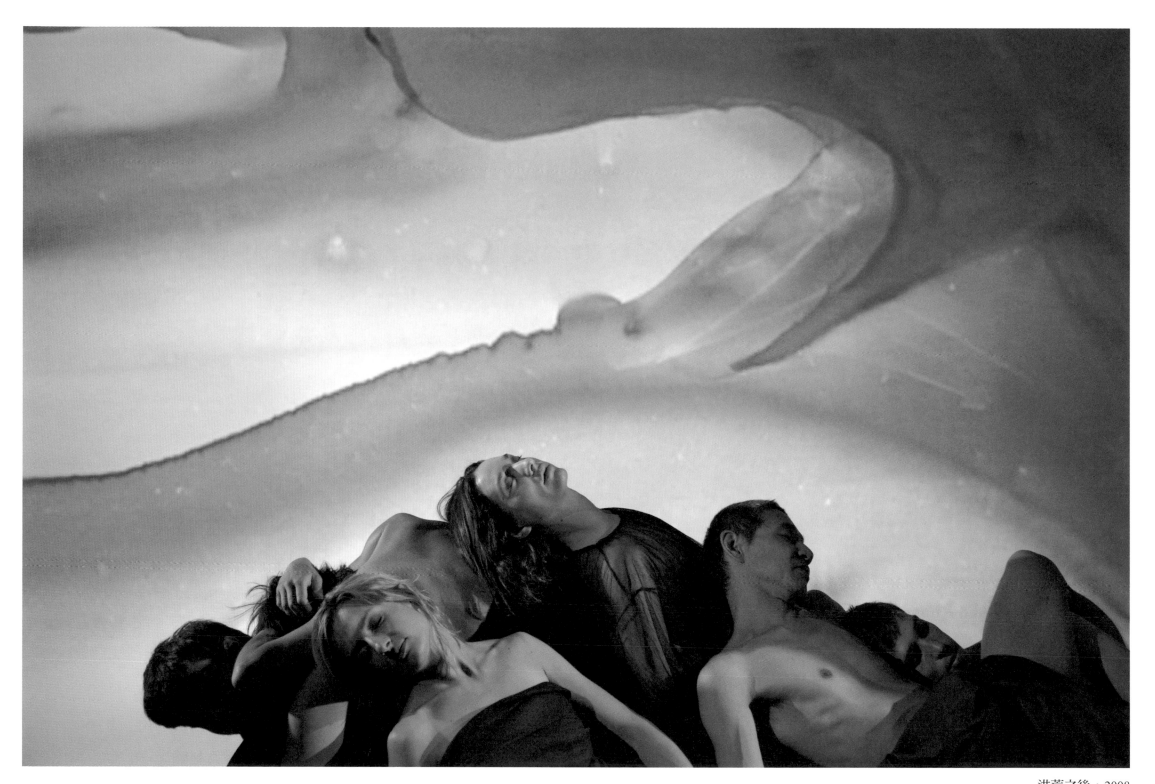

洪荒之後，2008
After the Flood, 2008

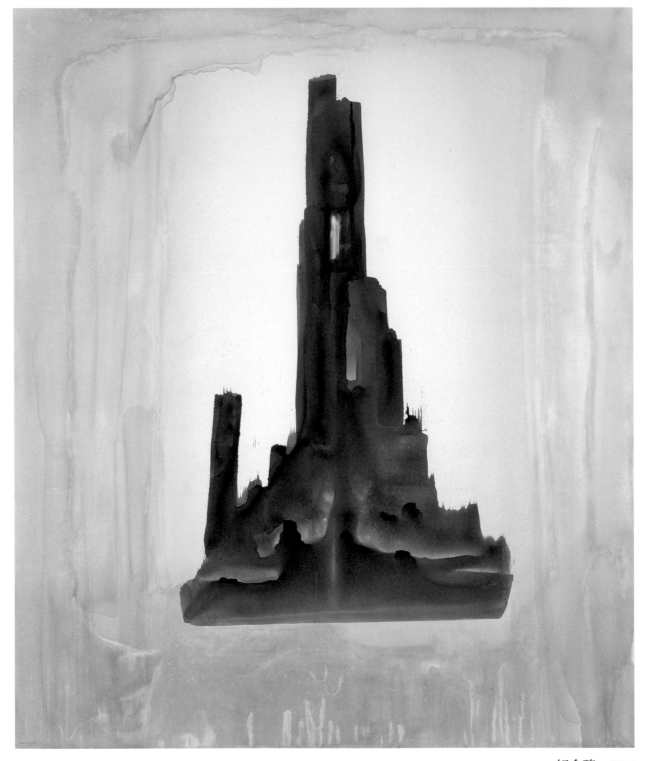

紀念碑，2007
The Monument, 2007
Ink in Canvas, 240 cm x 300 cm

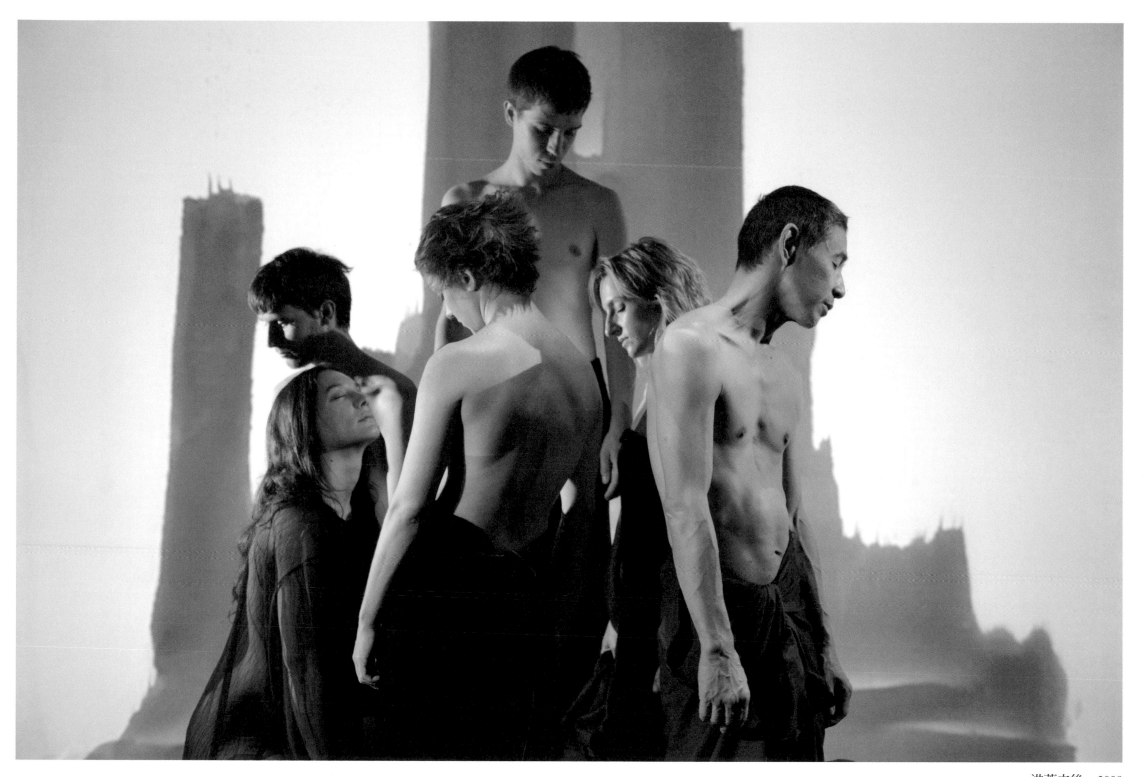

洪荒之後，2008
After the Flood, 2008

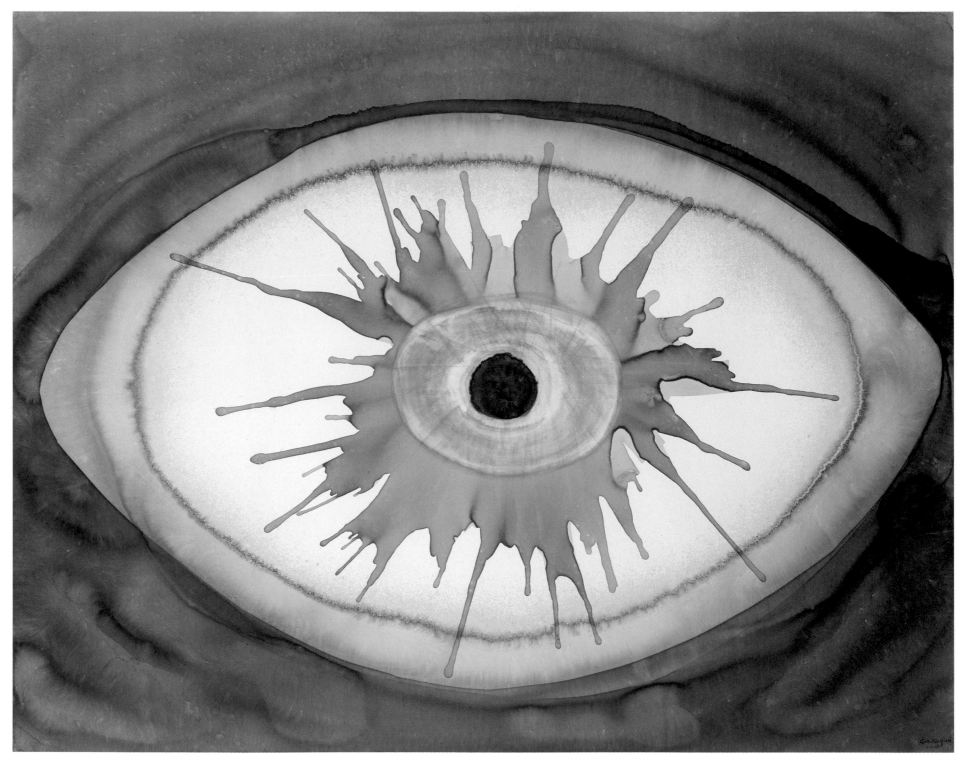

失明，2007
Losing Sight, 2007
Ink in Canvas, 114 cm x 146 cm

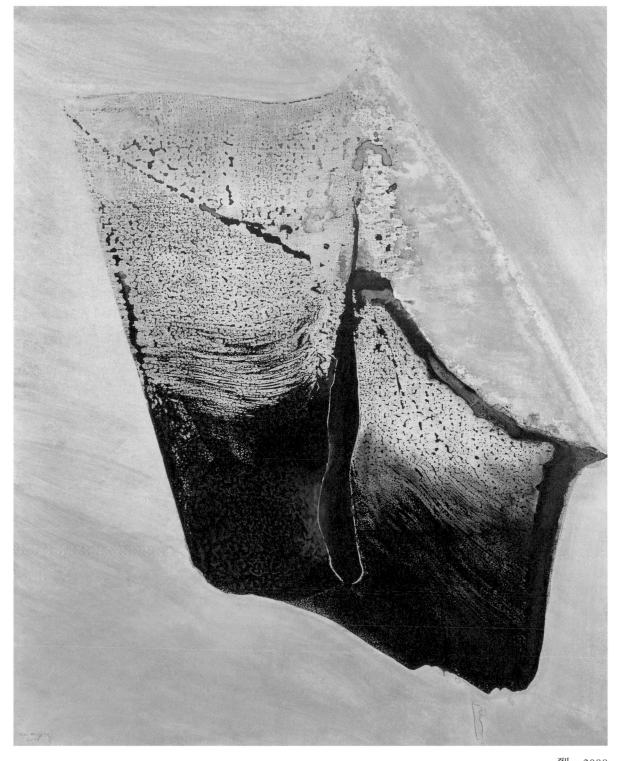

裂，2008
Crack, 2008
Ink in Canvas, 130 cm x 161 cm

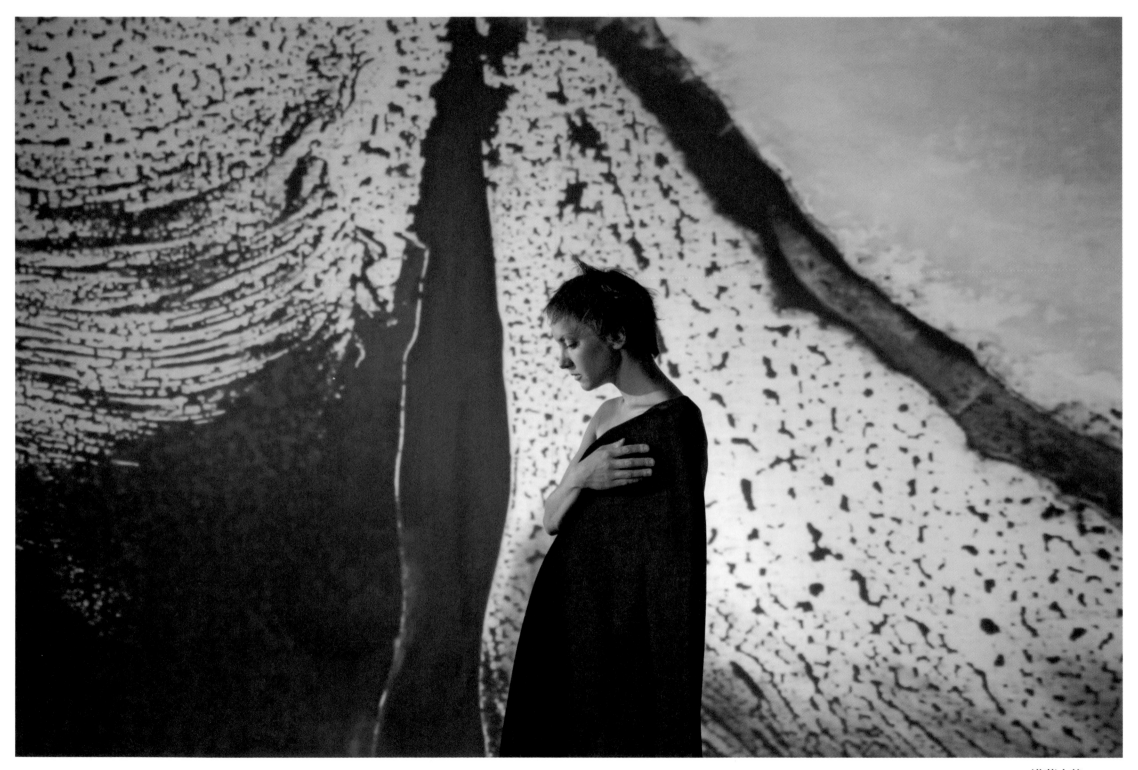

洪荒之後，2008
After the Flood, 2008

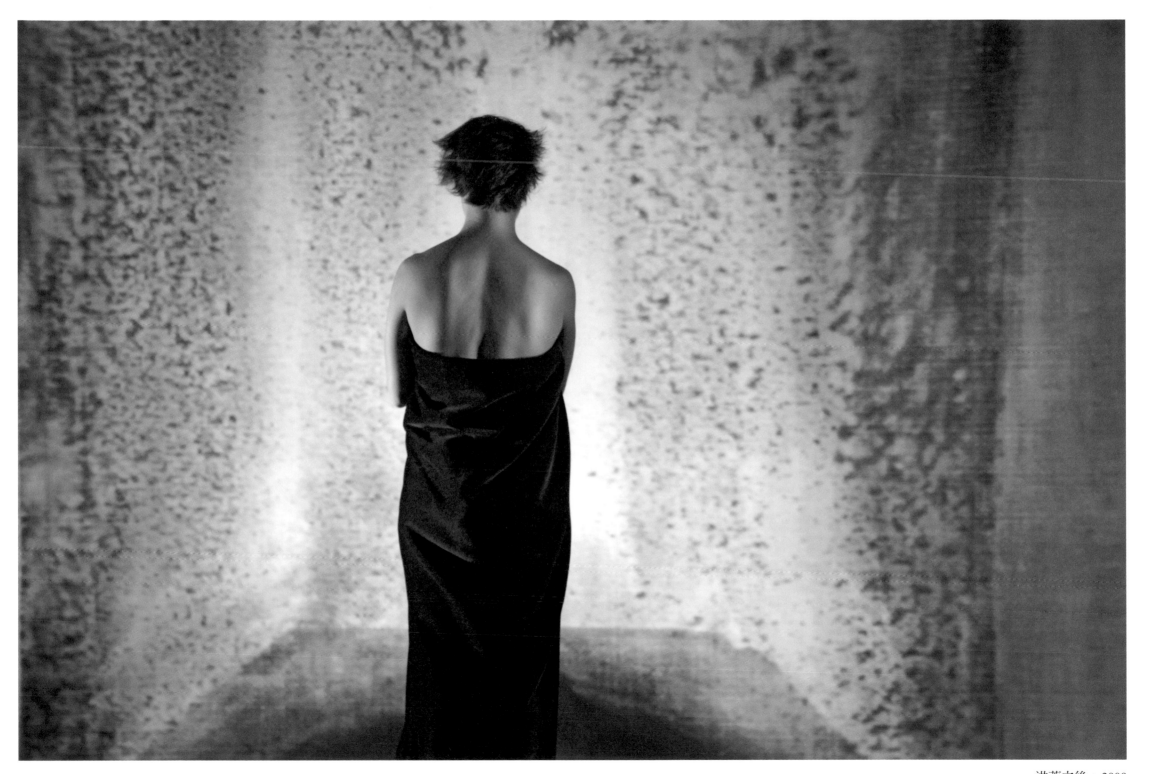

洪荒之後，2008
After the Flood, 2008

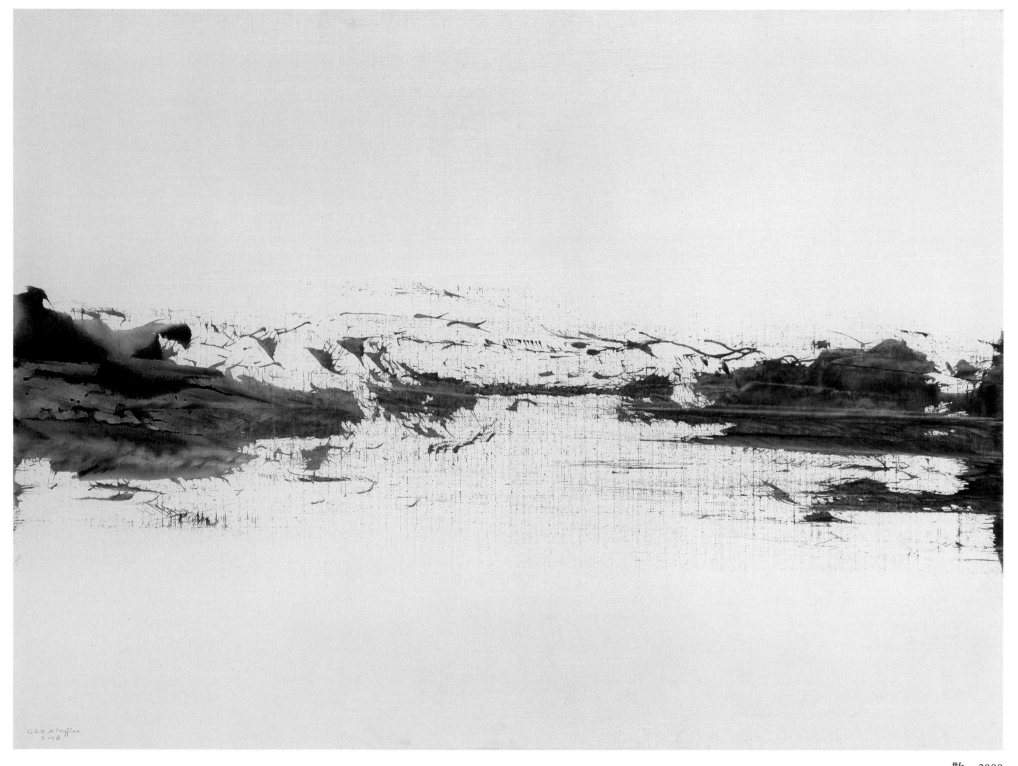

散，2008
Dispersion, 2008
Ink in Canvas, 60 cm x 81 cm

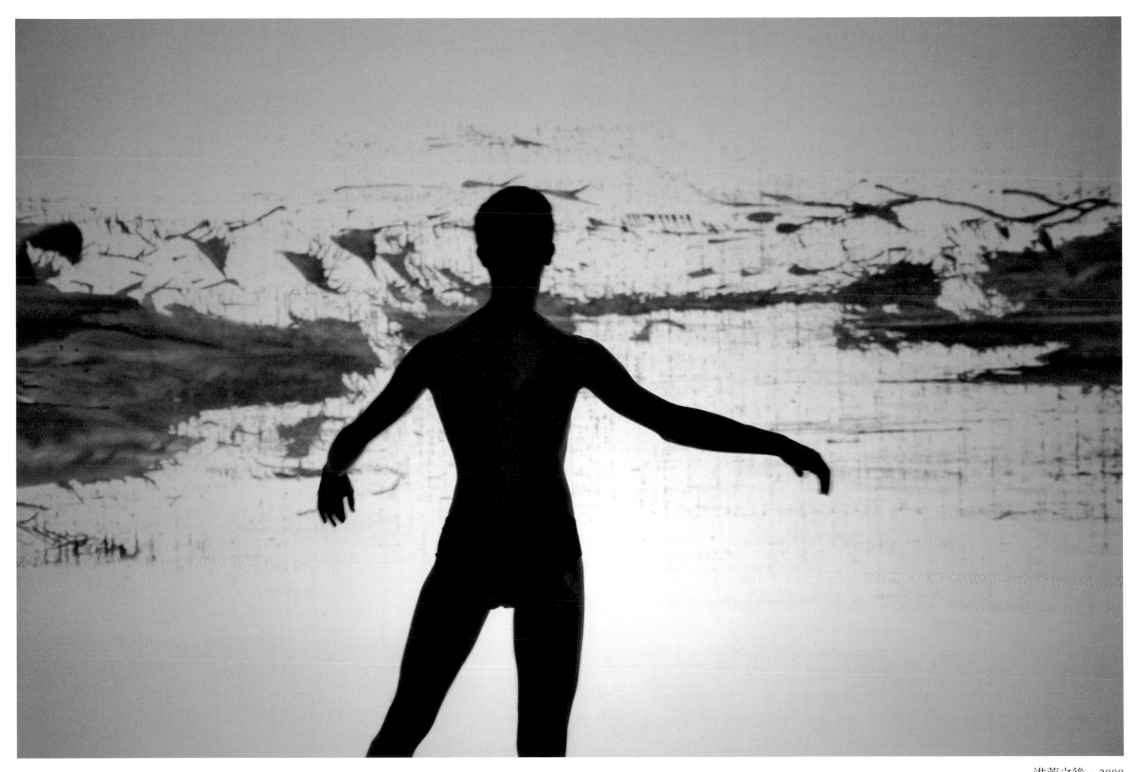

洪荒之後，2008
After the Flood, 2008

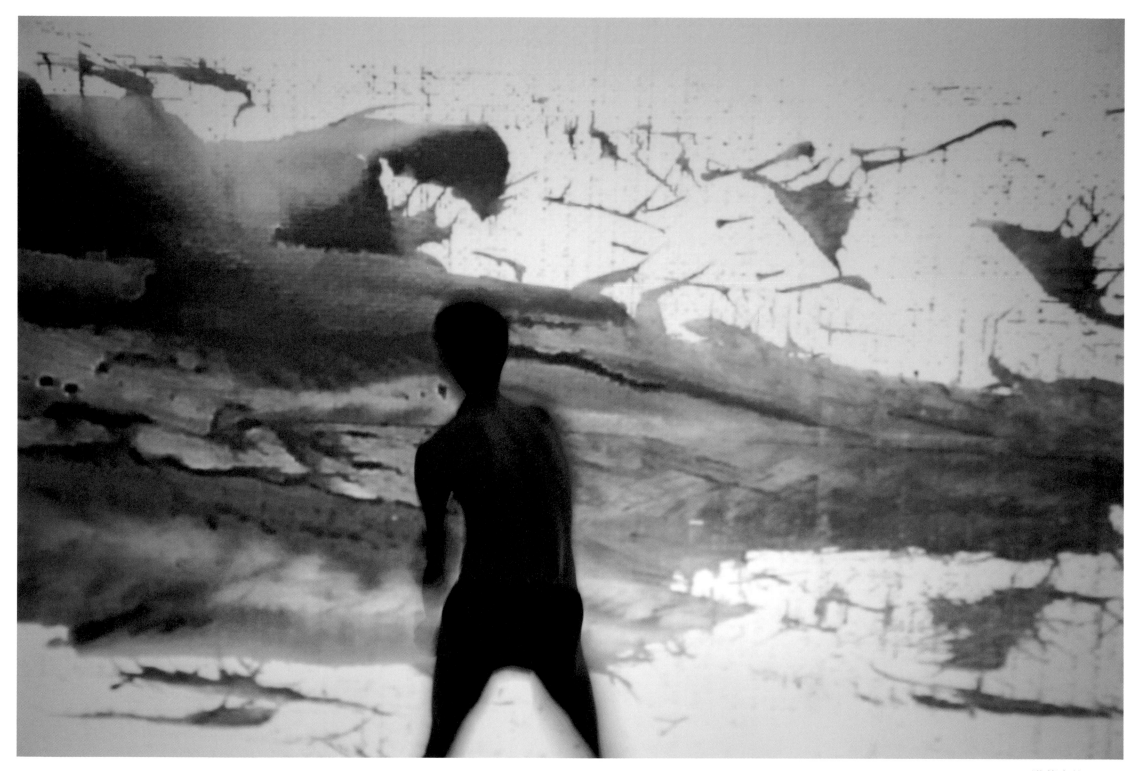

洪荒之後，2008
After the Flood, 2008

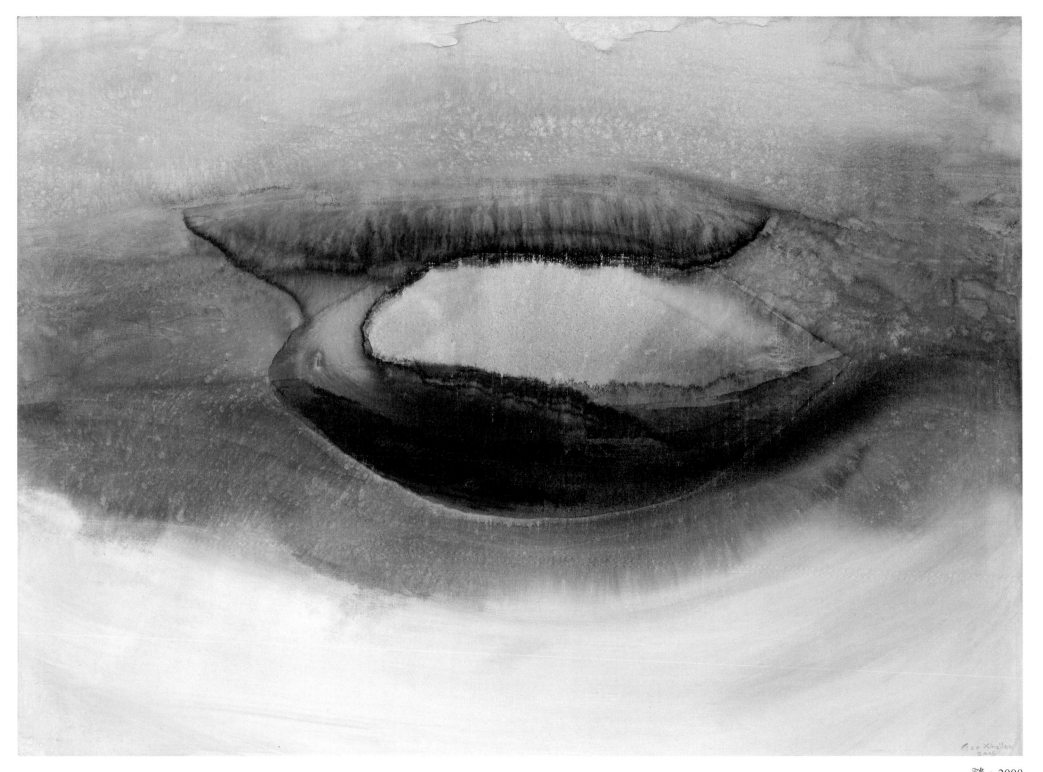

謎，2008
Enigma, 2008
Ink in Canvas, 73 cm x 100 cm

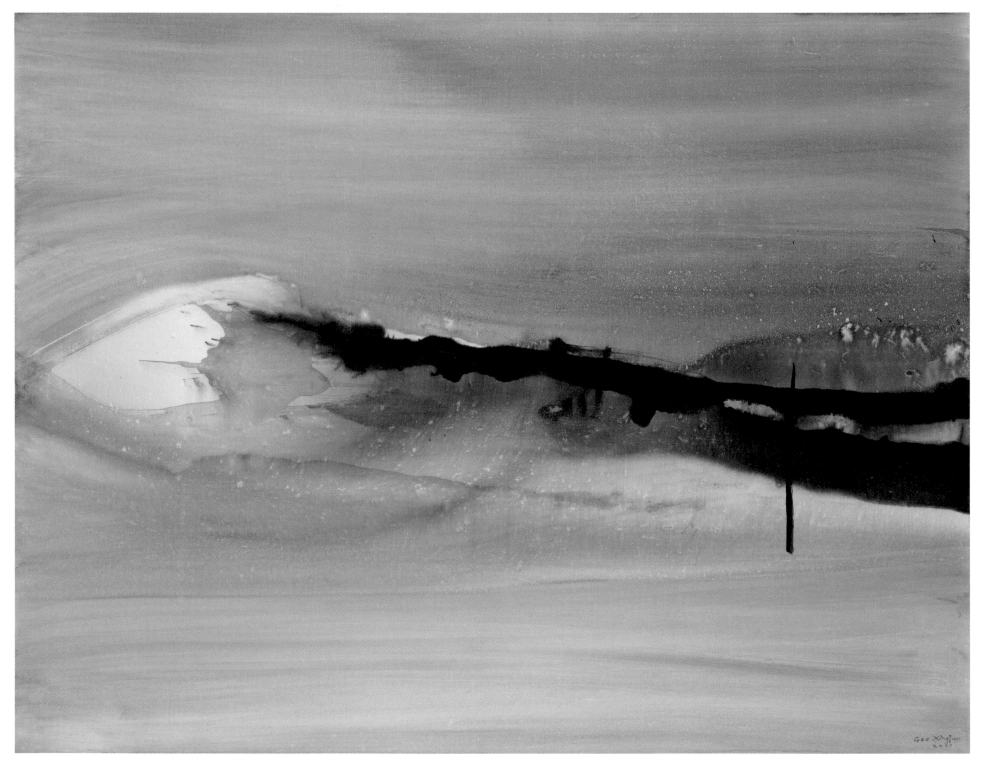

霧氣·2007
Mist, 2007
Ink in Canvas, 89 cm x 116 cm

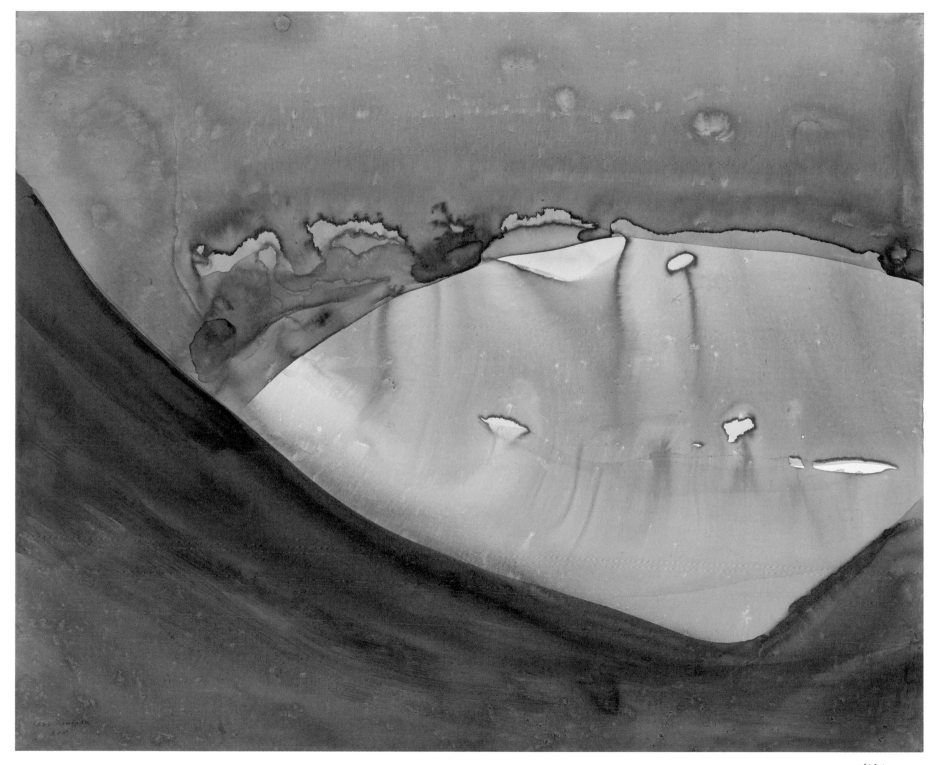

奇幻，2007
Amazement, 2007
Ink in Canvas, 81 cm x 100 cm

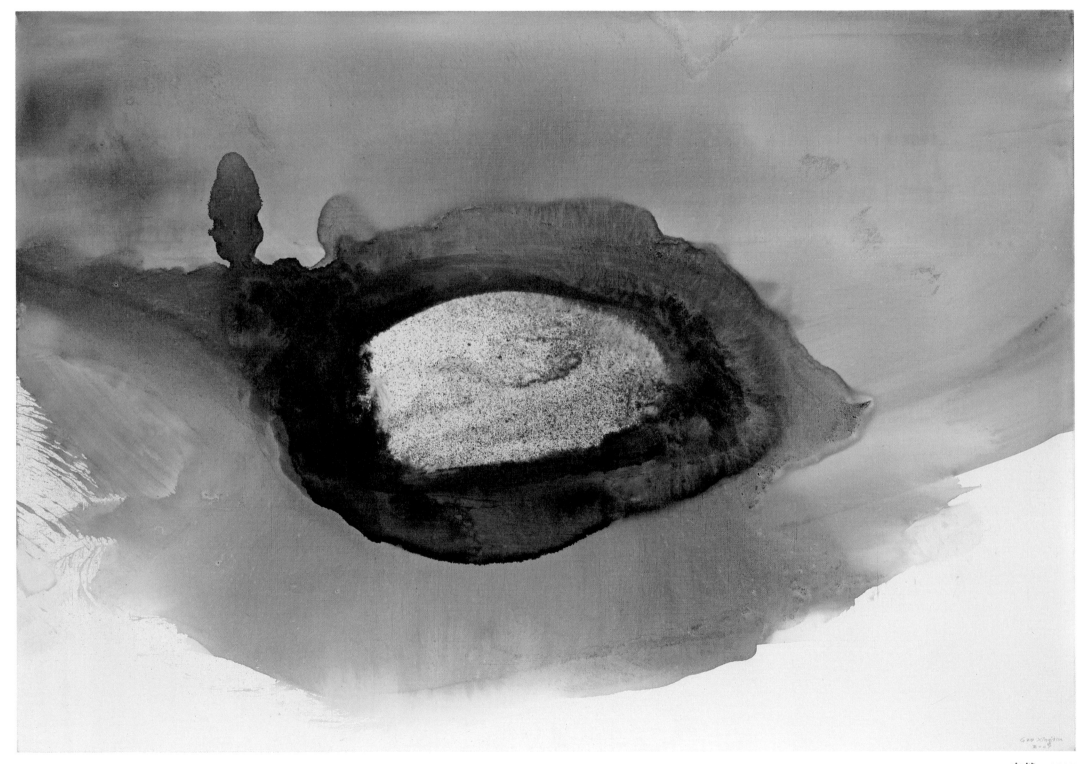

自然，2007
Nature, 2007
Ink in Canvas, 81 cm x 116 cm

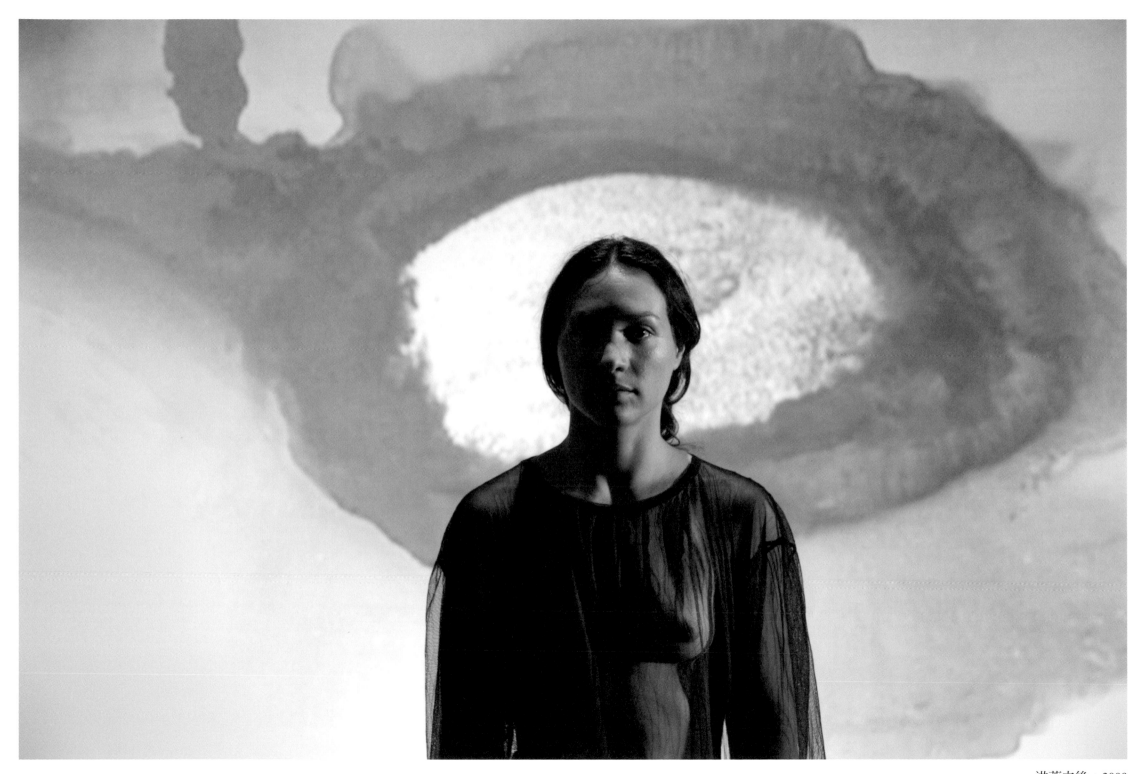

洪荒之後，2008
After the Flood, 2008

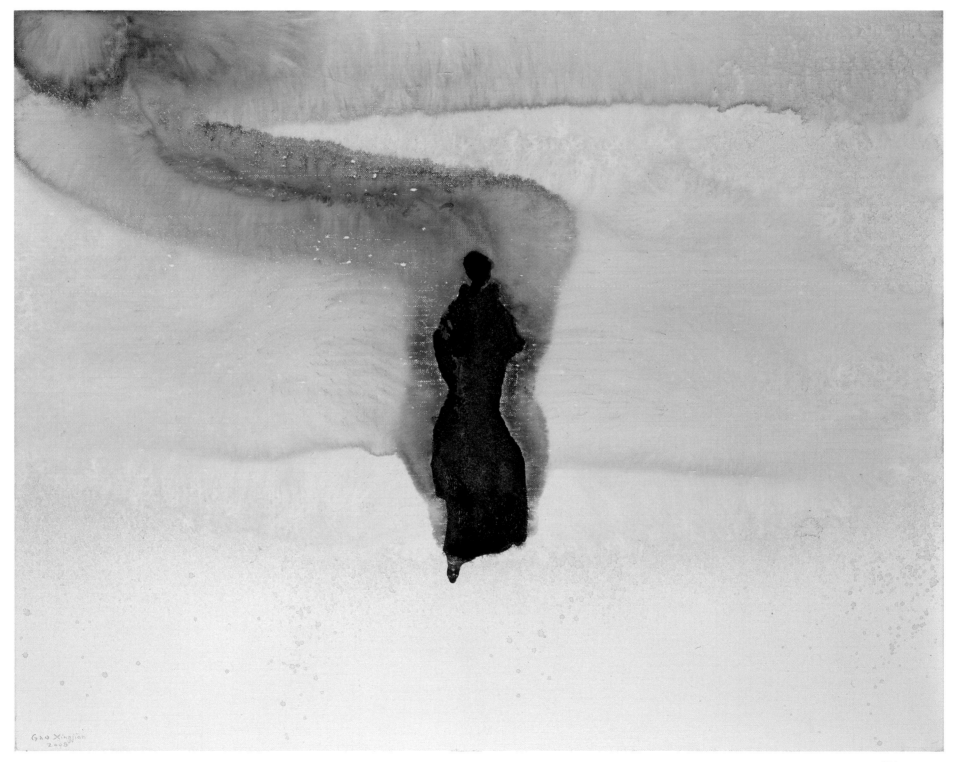

夢幻・2007
Illusion, 2007
Ink in Canvas, 81 cm x 100 cm

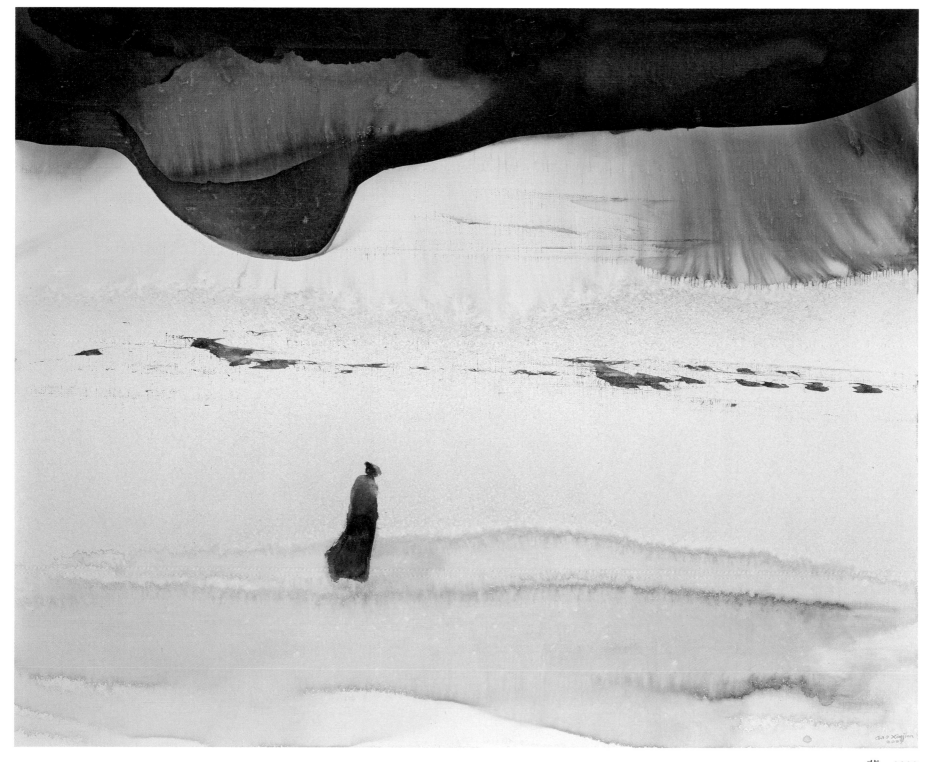

夢，2008
Dream, 2008
Ink in Canvas, 73 cm x 92 cm

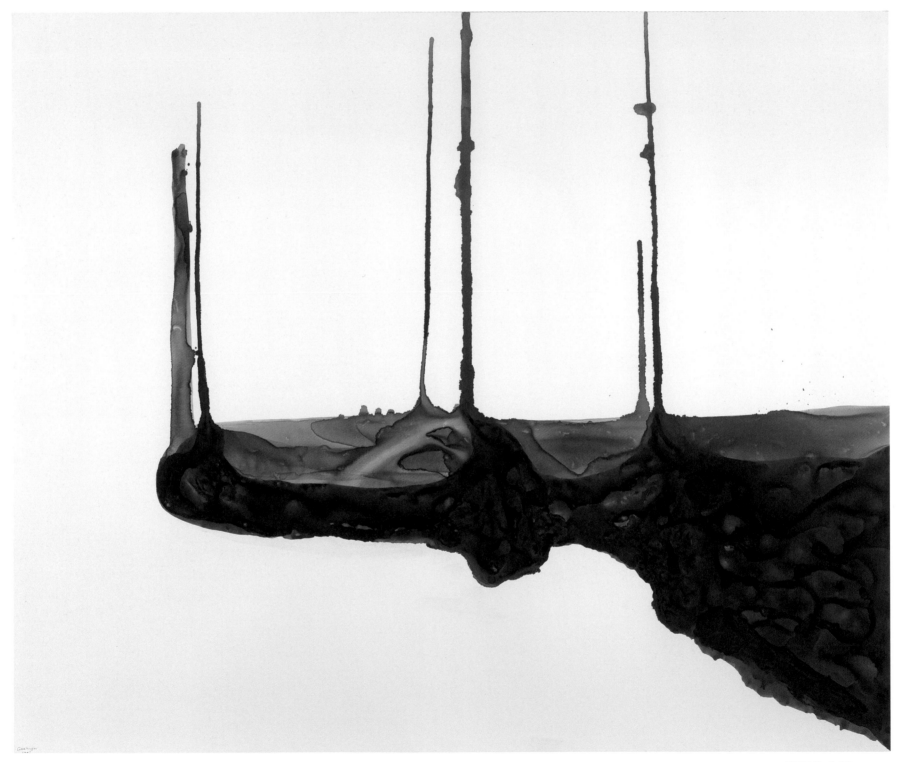

懸置的自然，2007
Suspended Nature, 2007
Ink in Canvas, 200 cm x 240 cm

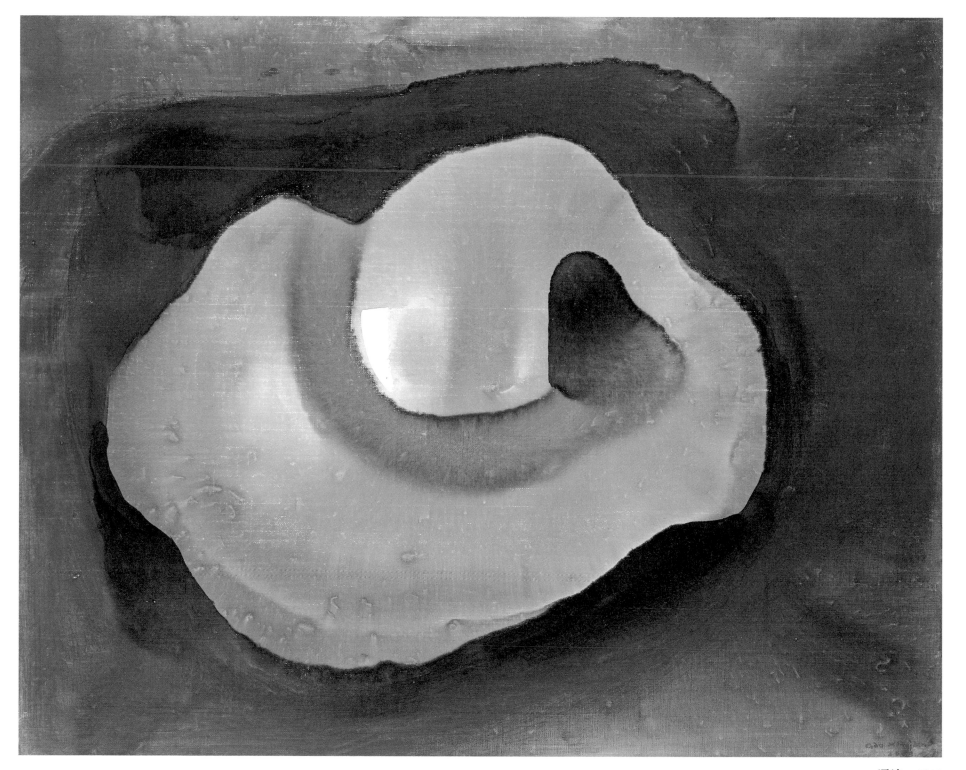

通途，2008
Passage, 2008
Ink in Canvas, 73 cm x 92 cm

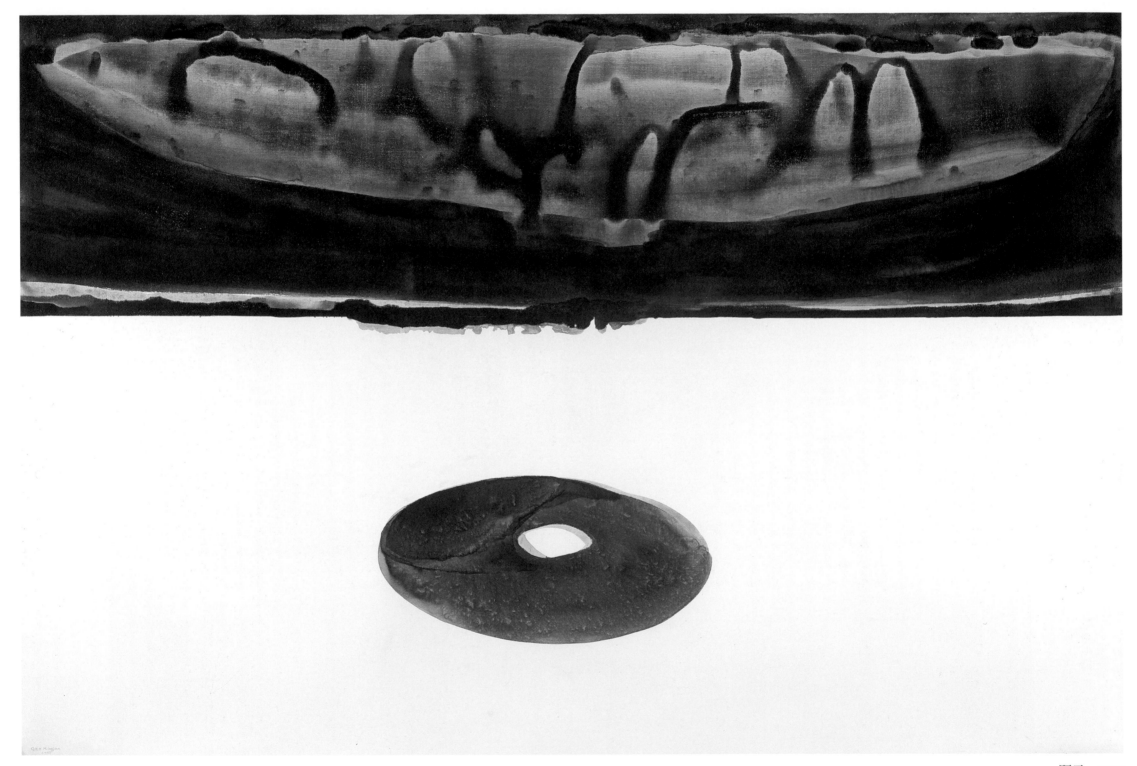

顯示，2006
Demonstration, 2006
Ink in Canvas, 200 cm x 300 cm

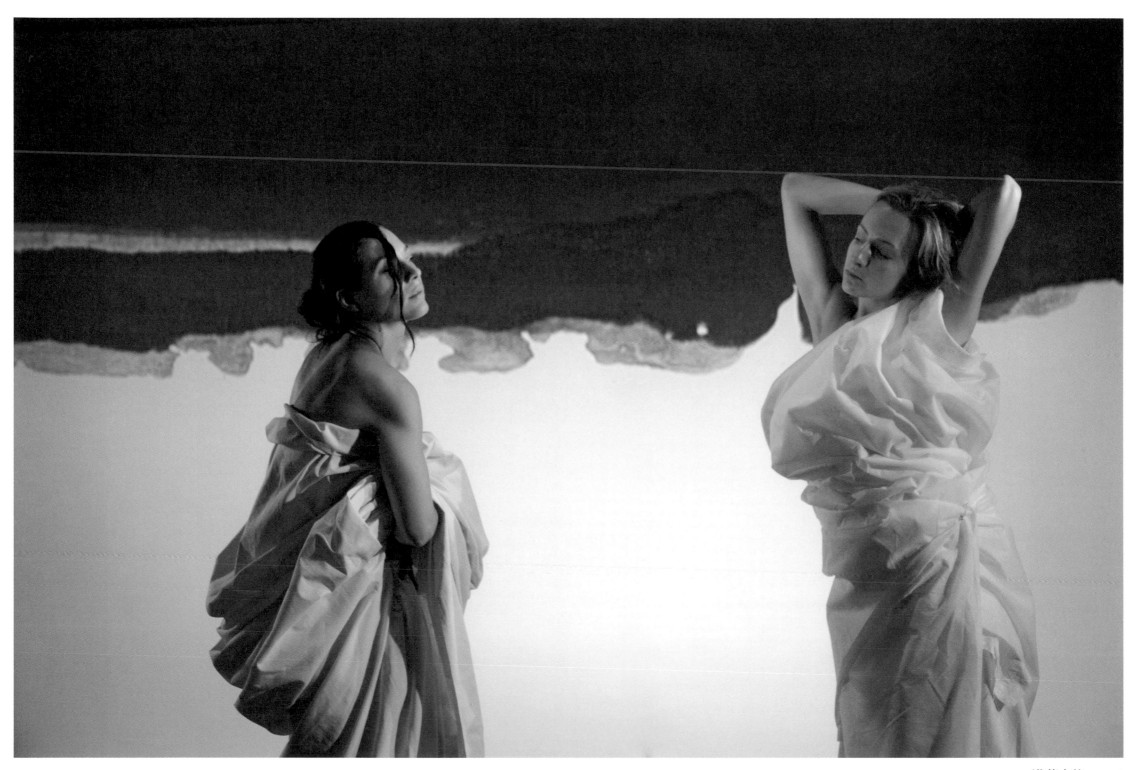

洪荒之後，2008
After the Flood, 2008

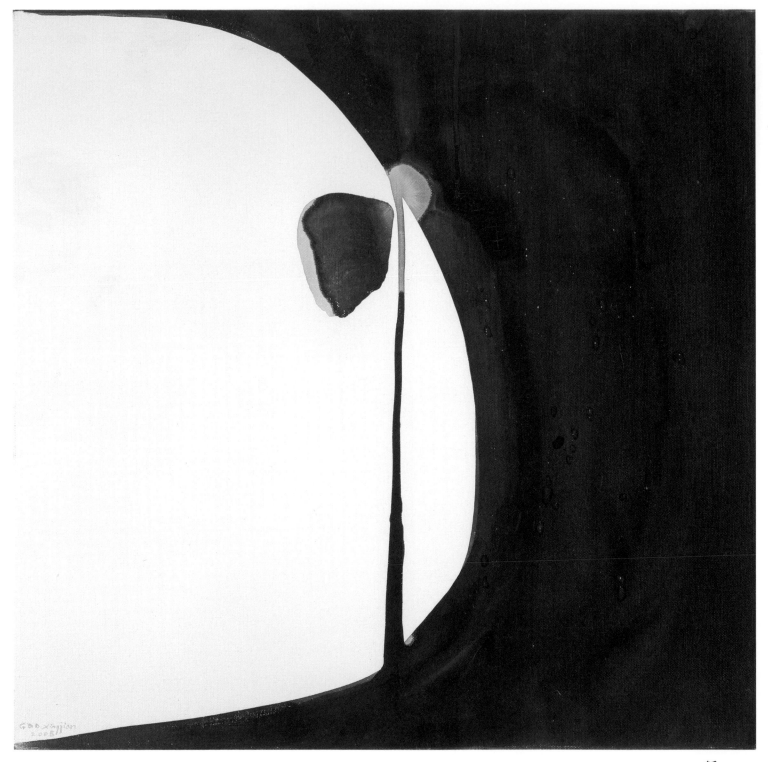

靜．2008
Silence, 2008
Ink in Canvas, 60 cm x 60 cm

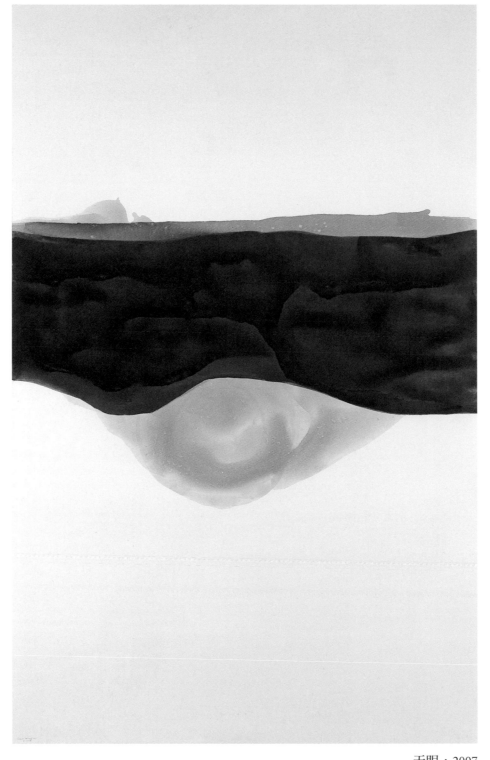

天眼，2007
Eye in the Sky, 2007
Ink in Canvas, 240 cm x 150 cm

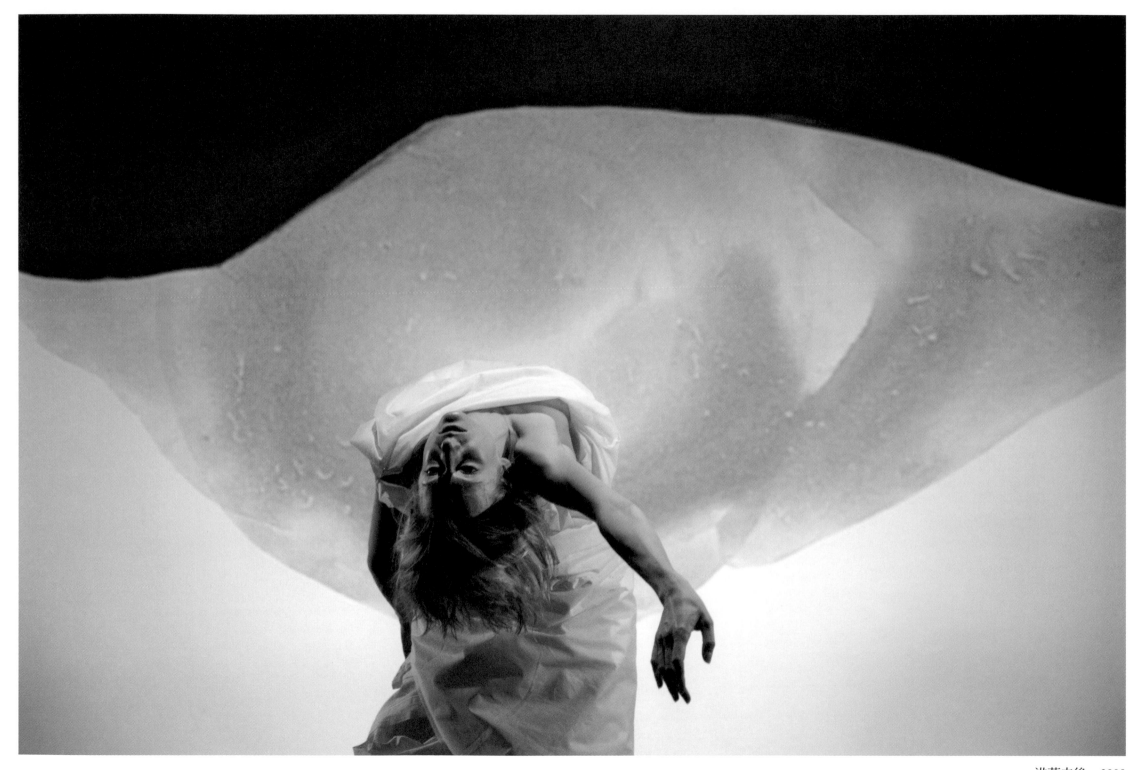

洪荒之後，2008
After the Flood, 2008

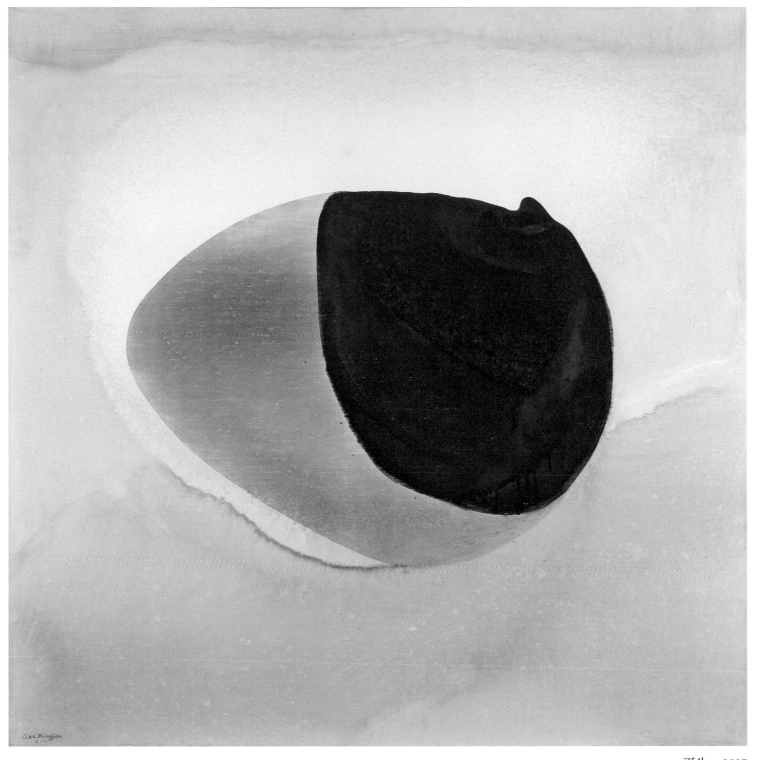

誕生，2007
Birth, 2007
Ink in Canvas, 100 cm x 100 cm

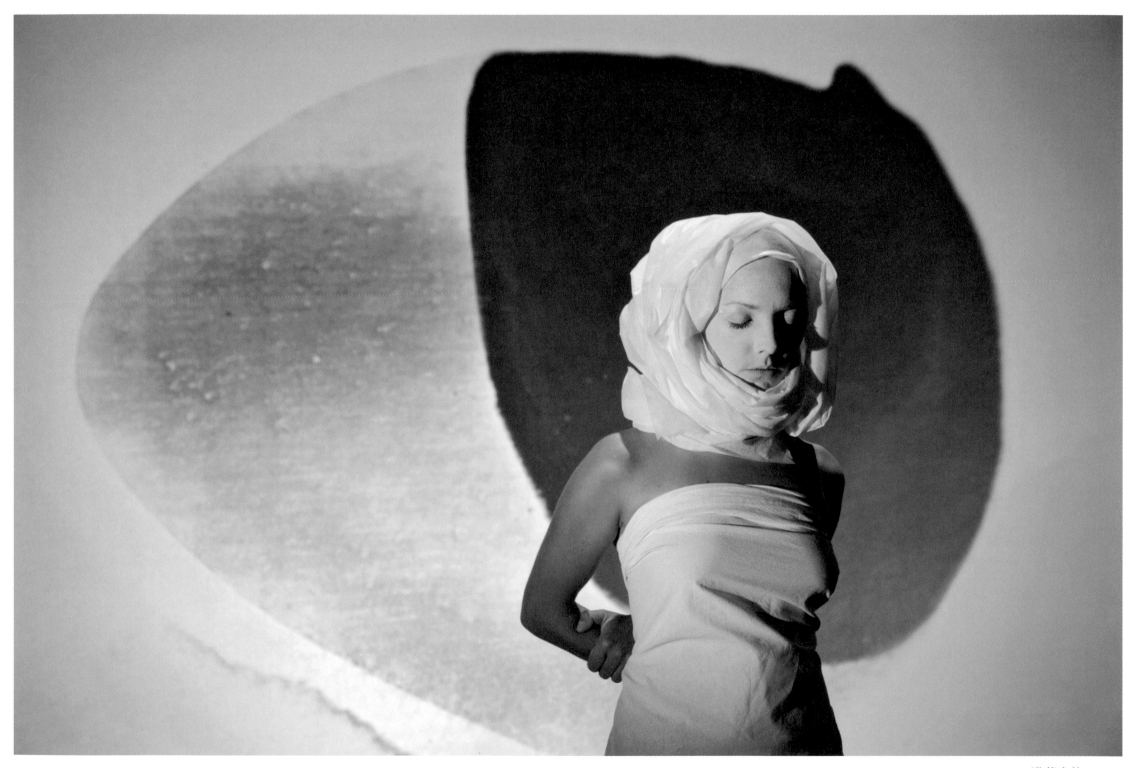

洪荒之後，2008
After the Flood, 2008

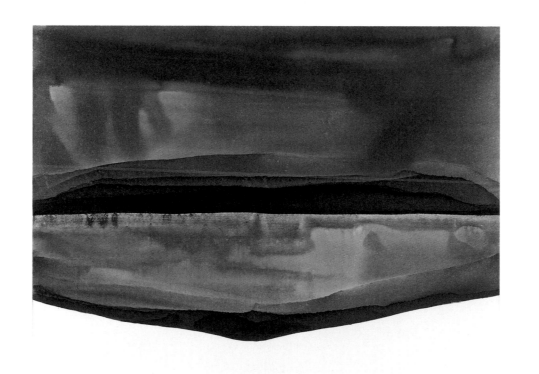

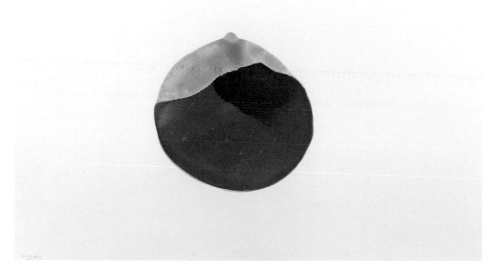

啟示，2007
Enlightment, 2007
Ink in Canvas, 100 cm x 100 cm

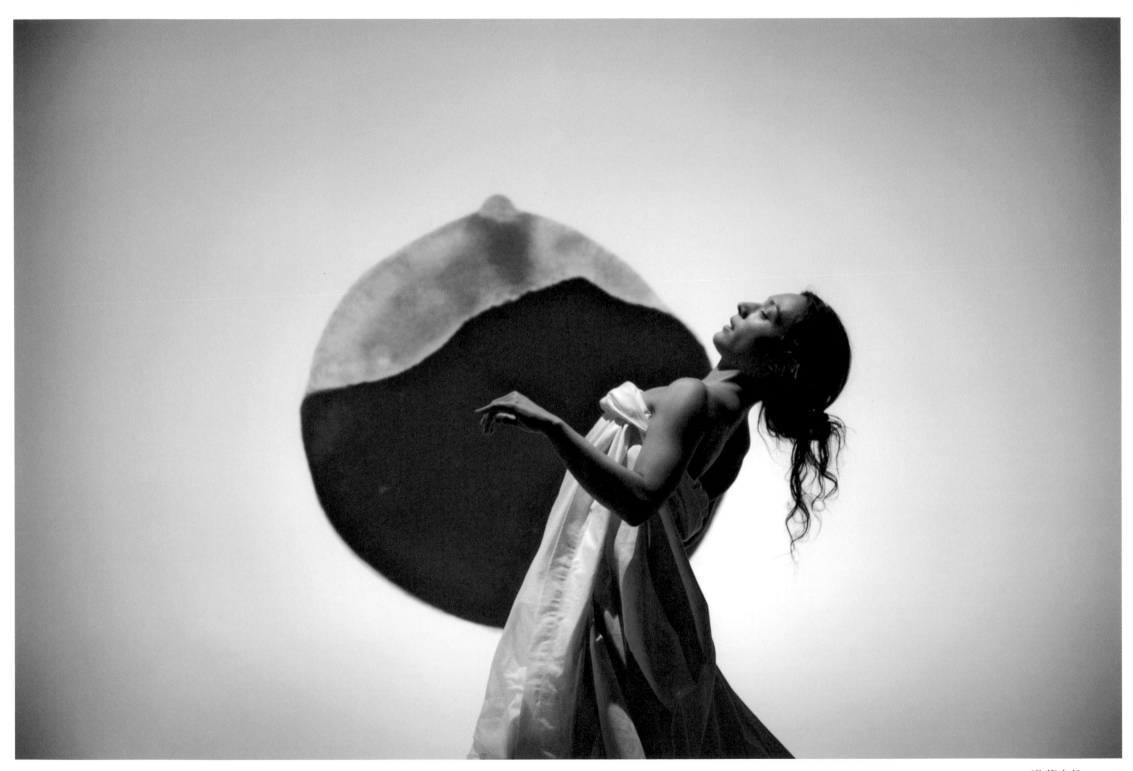

洪荒之後，2008
After the Flood, 2008

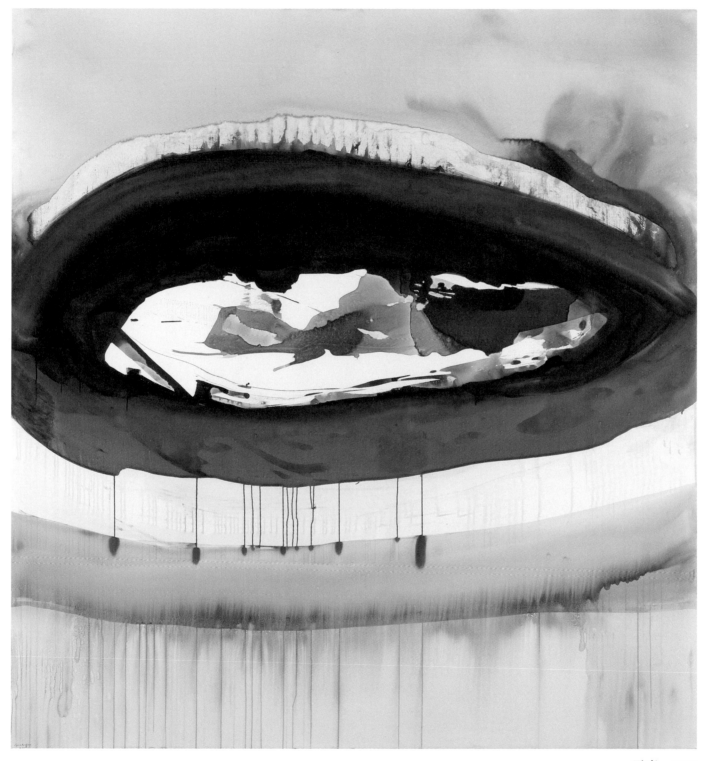

雪意，2007
Snow, 2007
Ink in Canvas, 240 cm x 225 cm

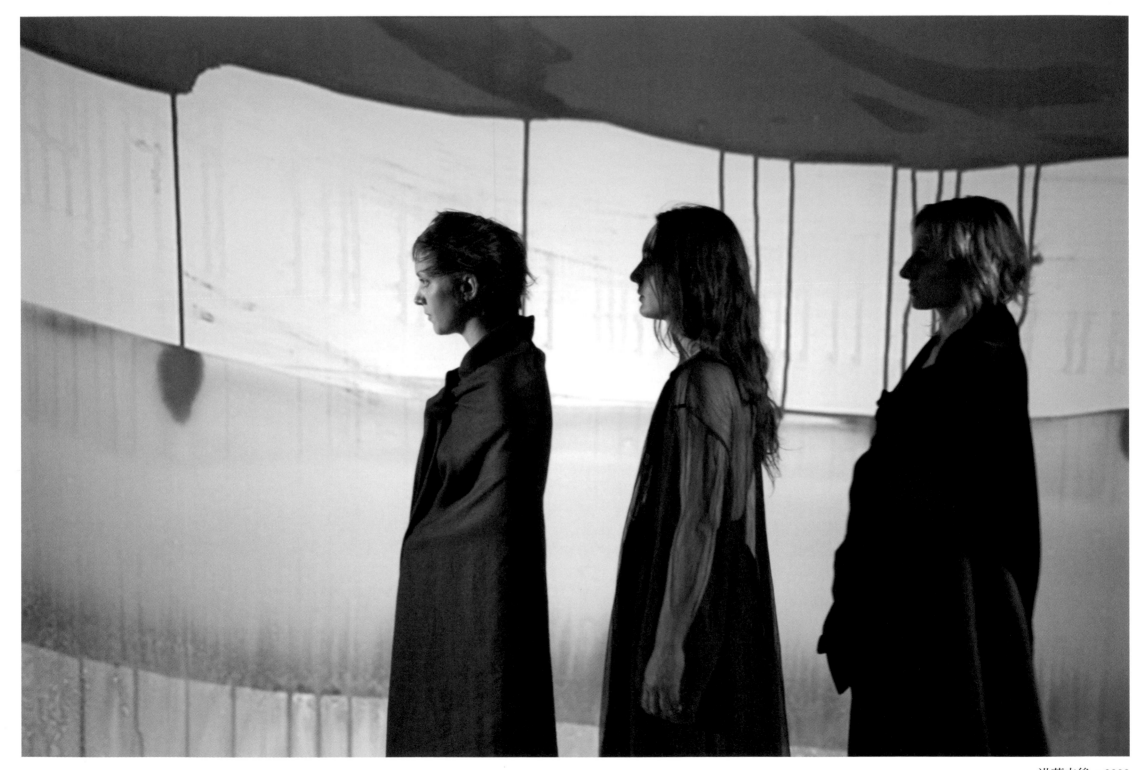

洪荒之後，2008
After the Flood, 2008

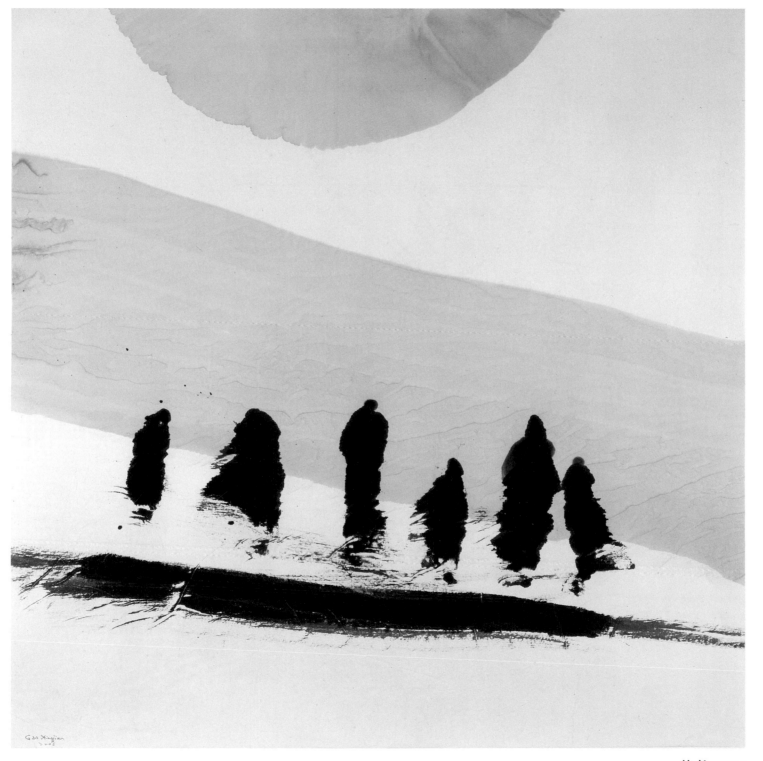

使者，2006
The Messengers, 2006
Ink in Canvas, 200 cm x 300 cm

高行健 ⁄

　　國際著名的全方位藝術家、集小說家、戲劇家、詩人、戲劇和電影導演、畫家和理論家於一身。1940 年生於中國江西贛州，1997 年取得法國籍，定居巴黎。2000 年獲諾貝爾文學獎。他的小說和戲劇關注人類的生存困境，瑞典學院在諾貝爾獎授獎詞中以「普世的價值、刻骨銘心的洞察力和語言的豐富機智」加以表彰。

　　他的小說已譯成四十種文字，全世界廣為發行。其劇作在歐洲、亞洲、北美洲、南美洲和澳大利亞頻頻演出。他的畫作在具象與抽象之間，呈現一派內在的心象，在歐洲、亞洲和美國的許多美術館、藝術博覽會和畫廊已有七十多次個展。近年來，他又拍攝了三部沒有故事和情節的電影詩。

　　他還榮獲法國藝術與文學騎士勳章、法國榮譽軍團騎士勳章、法國文藝復興金質獎章、義大利費羅尼亞文學獎、義大利米蘭藝術節特別致敬獎、美國終身成就學院金盤獎、美國紐約公共圖書館雄獅獎、盧森堡歐洲貢獻金獎；香港中文大學、法國馬賽—普羅旺斯大學、比利時布魯塞爾自由大學、臺灣大學、臺灣的中央大學和中山大學皆授予他榮譽博士。此外，2003 年法國馬賽市舉辦了他的大型藝術創作活動「高行健年」，2008 年法國駐香港及澳門總領事館和香港中文大學舉辦了「高行健藝術節」，2011 年德國紐倫堡—埃爾朗根大學舉辦了《高行健：自由、命運與預測》大型國際研討會。

Biography

Gao Xingjian, the 2000 Nobel Laureate for Literature, is an internationally celebrated artists across genres; he is a novelist, a playwright, a poet, a painter, a photographer and a filmmaker.

Born in Ganzhou, China in 1940, Gao has been living in France since 1987 and has been a French citizen since 1997. Over the years, he has received numerous awards, including: Chevalier de l'Ordre des Arts et des Lettres, La Médaille d'Or de la Renaissance Française from France, Il Premio Litterario Feronia and La Milanesiana Award from Italy, the American Academy of Achievement, the Golden Plate Award, and the Library Lions from the New York Public Library from the United States, and La Medaille d'Or de la Fondation du Merite-Europeen from Luxemburg.

His novels and plays explore the survival and struggle of life. At the Nobel Prize award ceremony, the Swedish Academy stated that Gao received the award "for an oeuvre of universal validity, bitter insights and linguistic ingenuity". His writings have been translated into forty-one languages, and his plays continue to be produced in various theatres throughout the world each year. Since 1985, more than seventy solo exhibitions of Gao's ink paintings have been held in museums and galleries in Europe, the USA, and Asia; his works have also been selected for numerous group exhibitions and international art fairs.

高行健著作
Bibliographie

小說

1984 有隻鴿子叫紅唇兒（中篇小說集 , 十月文藝出版社，北京）

1989 給我老爺買魚竿（短篇小說集，聯合文學出版社，臺灣）

Buying a fishing rod for my grandfather , Harpercollins Publishers New York 2004

1990 靈山（長篇小說，聯經出版公司，臺灣）

Soul mountain, Harpercollins Publishers, New York 2000

1999 一個人的聖經（長篇小說，聯經出版公司，臺灣）

One Man's Bible, Harpercollins Publishers, New York, 2002

劇作

1982 絕對信號，（高行健戲劇集，群眾出版社，北京）

Absolute Signal (National Institute for Compilation and translation, Taiwan)

1983 車站（高行健戲劇集，群眾出版社，北京）

1984 現代折子戲四折（高行健戲劇集，群眾出版社，北京）

1985 獨白（高行健戲劇集，群眾出版社，北京）

1985 野人（高行健戲劇集，群眾出版社，北京）

Wild Man (Asia Theatre Journal Volume 7 No.2, U.S.A, University of Hawaii Press, U.S.A.)

1986　彼岸（聯合文學出版社, 臺灣）

The Other Shore（The Chinese University Press, Hong Kong）

1987　冥城（聯合文學出版社, 臺灣）

City of the Dead (City of the Dead and Song of the Night, The Chinese University Press,Hong Kong)

1988　聲聲慢變奏（冥城，聯合文學出版社，臺灣）

1989　山海經傳（聯合文學出版社，臺灣）

Of Mountains and Seas（The Chinese University Press, Hong Kong）

1989　逃亡（聯合文學出版社，臺灣）

Escape (*Escape & The Man Who Questions Death*, The Chinese University Press, Hong Kong)

1991　生死界（聯合文學出版社, 臺灣）

Between Life and Death (The Other Shore, The Chinese University Press, Hong Kong)

1992　對話與反詰（聯合文學出版社，臺灣）

Dialogue and Rebuttal (The Other Shore, The Chinese University Press, Hong　Kong)

1993　夜遊神（聯合文學出版社，臺灣）

Nocturnal Wanderer (The Other Shore, The Chinese University Press, Hong　Kong)

1995　周末四重奏（聯經出版公司，臺灣）

Weekend　Quartet (The Other Shore, The Chinese University Press, Hong Kong)

1997　八月雪（聯經出版公司，臺灣）

Snow in August (Chinese University Press, Hong Kong)

2003　叩問死亡（聯經出版公司，臺灣）

The Man Who Questions Death (Escape & The Man Who Questions Death , The Chinese University Press, Hong Kong)

2007　夜間行歌（遊神與玄思，聯經出版公司，臺灣）

Song of the Night (City of the Dead and Song of the Night, The Chinese University Press, Hong　Kong)

詩集

2012　遊神與玄思（聯經出版公司，臺灣）

論著

1981　現代小說技巧初探（花城出版社，廣州，中國）

1988　對一種現代戲劇的追求（中國戲劇出版社，北京）

1996　沒有主義（聯經出版公司，臺灣）

　　　Cold Literature（Chinese University Press, Hong Kong）

　　　The Case for Literature（Yale University press, U.S.A.）

2000　另一種美學（聯經出版公司，臺灣）

2008　論創作（聯經出版公司，臺灣）

　　　Gao Xingjian: Aesthetics and Creation (Cambria Press, New York)

2010　論戲劇（聯經出版公司，臺灣）

2014　自由與文學（聯經出版公司，臺灣）

電影

2006　側影或影子（*Silhouette/Shadow*）

2008　洪荒之後（*After the Flood*）

2013　美的葬禮（*Requiem for Beauty*）

藝術畫冊

1986　高行健水墨（萊布尼茲基金會，柏林）

　　　Gao Xingjian Tusche Rausch (Leibniz Gesellschaft, Berlin)

1993　高行健（布爾日市文化中心，法國）

　　　Gao Xingjian (Maison de la Culture de Bourges, France)

1995　高行健水墨作品展（臺北市立美術館，臺灣）

　　　Ink Paintings by Gao Xingjian（Taipei Fine Arts Museum, Taiwan）

2000　高行健水墨 1983-1993 （莫哈特藝術研究所，弗萊堡，德國）

　　　Gao Xingjian Tuschmalerei 1983-1993 (Morat Institut for Kunst and Kunstwissenshaft, Freiburg, Germany)

2001　墨與光（文化建設委員會，臺灣）

　　　Darkness & Light （ National Museum of History, Taiwan）

2002　回到繪畫 （哈珀柯林斯出版社，紐約）

　　　Returne to Painting（HarperCollins Publishers, New York）

2002　高行健 （蘇菲亞皇后國立美術館，馬德里）

　　　Gao Xingjian (Museo Nacional Centro de Arte Reina Sofia, Madrid)

2003　高行健 , 無字無符號 （壁毯博物館，普羅旺斯，法國）

　　　GaoXingjian, Ni mots ni signes (Musée des Tapisserie , Aix-en-Provence, France)

2005　高行健，無我之境，有我之境（新加坡美術館）

　　　Gao Xingjian, Experience (Singapore Art Museum, Singapore)

2007　高行健 世界末日（盧德維克博物館，科布倫斯，德國）

　　　Gao Xingjian La Fin du Monde (Ludwig Museum, Koblenz, Germany)

2007　高行健 具象與抽象之間 （聖母大學施尼特美術館，印第安那州，美國）

　　　Gao Xingjian Between Figurative and Abstract (Snite Musuem of Art, Notre Dame, Indiana, U.S.A.)

2007　側影或影子 高行健的電影藝術（宮杜爾出版社，巴黎）

　　　Silhouette/Shadow The Cinematic Art of Gao Xingjian (Editions Contours, Paris)

2008 高行建 洪荒之後（烏爾慈博物館，拉里奧亞，西班牙）

Gao Xingjian Despuès del diluvio (Museo Wurth La Rioja, Spain)

2009 高行健 洪荒之後 （星特拉現代藝術館，里斯本）

Gao Xingjian Depois do dilùvio (Wurth Potugal et Sintra Museu de Arte Moderna, Lisbon)

2010 高行健 世界終極（卡薩索勒里克藝術基金會，帕爾馬，西班牙）

Gao Xingjian Al Fons del Mon (Casal Solleric Fondacion Espal d'Art, Spain)

2013 高行健 靈魂的畫家（索伊出版社，巴黎）

Gao Xingjian Peintre de l'âme (Editions du Seuil, Paris)

2013 高行健 靈魂的畫家（亞洲水墨出版社，倫敦）

Gao Xingjian Painter of the Soule (Asia Ink, London)

2013 內在的風景 高行健繪畫（新學院出版社，華盛頓）

The Inner Landscape The Painting of Gao Xingjian (New Academia Publishing Washington)

2015 高行健 墨趣（哈贊出版社 ，巴黎）

Gao Xingjian Le Goût de l'encre (Editions Hazan, Paris)

主要個展

1985 北京人民藝術劇院，北京

The People's Art Theater, Beijing

1985 柏林市貝塔寧藝術館，柏林

Berliner Kansterhaus Bethanien, Berlin

1987 北方省文化廳，里爾，法國

Département de la culture, Lille, France

1988 滑鐵盧市文化館，法國

Office municipal des beaux-arts et de la culture, Wattrelos, France

1989 東方博物館，斯德哥爾摩

Ostasiatiska Museet, Stockholm

1993 布爾日市文化之家，法國
 Maison de la culture de Bourges, France

1995 臺北市立美術館，臺灣
 Taipei Fine Arts Museum, Taiwan

1997 斯邁爾藝術中心畫廊，紐約
 The Gallery Schimmel Center of the Arts, New York

2000 瑞典學院圖書館，斯德哥爾摩
 Bibliothèque de l'Académie Suédoise, Stockholm

2000 莫哈特藝術研究所，弗萊堡，德國
 Morat Institut for Kunst and Kunstwissenshaft, Freiburg, Germany

2001 主教宮藝術館，亞維農，法國
 Palais des Papes, Avignon, France

2001 歷史博物館，臺灣
 National History Museum, Taiwan

2002 蘇菲亞皇后國家美術館，馬德里
 Museo Nacional Centro de Arte Reina Sofia, Madrid

2003 孟斯市美術館，比利時
 Musée des beaux-arts de Mons, Belgium

2003 壁毯博物館，普羅旺斯，法國
 Musée des Tapisseries, Aix-en-Provence, France

2003 老慈善院博物館，馬賽，法國
 Musée de la Vieille Charité, Marseille, France

2004 巴塞隆納當代藝術中心，巴塞隆納，西班牙
 Centre culturel contemporain de Barcelone, Spain

2005 新加坡美術館，新加坡
 Singapore Art Museum, Singapore

2006 法國學院，柏林
Institut Français, Berlin

2006 伯爾尼美術館，伯爾尼，瑞士
Musée des Beaux-Arts de Berne, Switzerland

2007 路德維克博物館，科布倫斯，德國
Ludwig Museum, Koblenz , Germany

2007 聖母大學斯尼特藝術館，印第安那州，美國
Snite Museum of Art, University of Notre Dame, Indiana, U.S.A.

2008 ZKM 博物館，卡爾斯魯爾，德國
Museum ZKM, Karlsruher, Germany

2008 讀者圈基金會，巴塞隆納，西班牙
Circulo de Lectores, Barcelone, Spain

2008 烏爾茨博物館，拉里奧亞，西班牙
Museo Wurthe La Rioja, Spain

2009 星特拉現代藝術館，里斯本
Sintra Museu de Arte Moderna Coleccao Berardo, Lisbon

2009 利耶日現當代藝術館，利耶日，比利時
Musée de l'Art moderne et de l'Art contemporain de Liège, Belgium

2010 卡薩索勒利克藝術基金會，帕爾馬，西班牙
Casal Solleric Fondacio Palma Espal d'Art , Palma de Mallorca, Spain

2013 馬里蘭大學藝術畫廊，美國
The Art Gallery, University of Maryland, U.S.A.

2015 伊塞爾博物館，布魯塞爾
Musée d'Ixelles, Brussels

2015 比利時皇家美術館，布魯塞爾
Musées Royaux des Beaux-Arts de Belgique, Brussels

主要參展

1989　大皇宮美術館，具象批評年展，巴黎

　　　Grand Palais, Figuration Critique, Paris

1990　大皇宮美術館，具象批評年展，巴黎

　　　Grand Palais, Figuration Critique, Paris

1991　大皇宮美術館，具象批評年展，巴黎

　　　Grand Palais, Figuration Critique, Paris

　　　特列雅科夫畫廊， 具象批評巡迴展，莫斯科

　　　Trejiakov galerie, Figuration Critique, Moscou

　　　美術家協會畫廊，具象批評巡迴展，聖彼得堡

　　　Galerie de l'Association des Artistes, Figuration critique, Saint-Pétersbourg

1998　第十九屆國際古董與藝術雙年展，羅浮宮，巴黎

　　　XIXe Biennale Internationale des Antiquaires, Carrousel du Louvre, Paris

2000　巴黎藝術大展，羅浮宮，巴黎

　　　Art Paris, Carrousel du Louvre, Paris

2003　當代藝術博覽會，巴黎

　　　Foire Internationale d'Art Contemporain, Paris

2004　當代藝術博覽會，巴黎

　　　Foire Internationale d'Art Contemporain, Paris

2005　巴黎藝術大展，羅浮宮，巴黎

　　　Art Paris, Carousel du Louvre, Paris

2006　第二十四屆布魯塞爾當代藝術博覽會，布魯塞爾

　　　Brussels 24th Contemporary Art Fair, Brussels

2006　蘇黎世藝術博覽會，瑞士

　　　Kunst 06, Zurich, Switzerland

2007 蘇黎世藝術博覽會，瑞士
 Kunst 07, Zurich, Switzerland
2008 巴黎藝術大展，大皇宮，巴黎
 Art Paris, Grand Palais, Paris
2012 第十二屆布魯塞爾古董與藝術展，布魯塞爾
 BRAFA12 Brussels Antiques & Fine Arts Fair, Brussels
2012 巴黎藝術大展，大皇宮美術館，巴黎
 Art Paris, Grand Palais, Paris
2013 巴黎藝術大展，大皇宮美術館，巴黎
 Art Paris, Grand Palais, Paris
2014 巴黎藝術大展，大皇宮美術館，巴黎
 Art Paris, Grand Palais, Paris
2015 第十五屆布魯塞爾古董與藝術博覽會，布魯塞爾
 BRAFA 15, Brussels Antiques & Fine Art Fair, Brussels

公共收藏

莫哈特藝術研究所，德國
Morat Institut for Kunst and Kunstwissenshaft, Germany
萊布尼茲基金會，柏林
Leibnitz Gesellschaft fur Kulturellen Austauch, Berlin
東方博物館，斯德哥爾摩
Ostasiatiska Museet, Stockolm
現代藝術博物館，斯德哥爾摩
Musée des arts modernes, Stockholm
臺北市立美術館，臺灣
Taipei Fine Arts Museum, Taiwan

國立歷史博物館，臺灣

National History Museum, Taiwan

諾貝爾基金會，斯德哥爾摩

Nobel Foundation, Stockholm

馬賽市政府

Ville de Marseille

香港中文大學

The Chinese University of Hong Kong

新加坡美術館

Singapore Art Museum

馬賽─普羅旺斯大學圖書館 , 法國

Bibliothèque de l'Université de Marseille-Provence, France

烏爾茲博物館，拉里奧亞，西班牙

Museo Wurth La Rioja, Spain

比利時皇家美術館，布魯塞爾

Musées Royaux des Beaux-Arts de Belgique, Brussls

洪荒之後

2015年4月初版　　　　　　　　　　　　　定價：新臺幣1200元

有著作權・翻印必究
Printed in Taiwan.

著　　　者　高　行　健
發　行　人　林　載　爵

出　版　者　聯經出版事業股份有限公司
地　　　址　台北市基隆路一段180號4樓
編輯部地址　台北市基隆路一段180號4樓
叢書主編電話　(02)87876242轉229
台北聯經書房　台北市新生南路三段94號
電　　　話　(02)23620308
台中分公司　台中市北區崇德路一段198號
暨門市電話：(04)22312023
台中電子信箱　e-mail：linking2@ms42.hinet.net
郵政劃撥帳戶第0100559-3號
郵撥電話　(02)23620308
印　刷　者　文聯彩色製版印刷有限公司
總　經　銷　聯合發行股份有限公司
發　行　所　新北市新店區寶橋路235巷6弄6號2樓
電　　　話　(02)29178022

叢書主編　李　佳　姍
整體設計　江　宜　蔚

行政院新聞局出版事業登記證局版臺業字第0130號

國家圖書館出版品預行編目資料

洪荒之後/高行健著．初版．臺北市．聯經．2015年
4月（民104年）．120面．25.5×36公分
ISBN　978-957-08-4549-5（精裝）

1.攝影集

958.2　　　　　　　　　　　　　　104004852